Mike Marshall

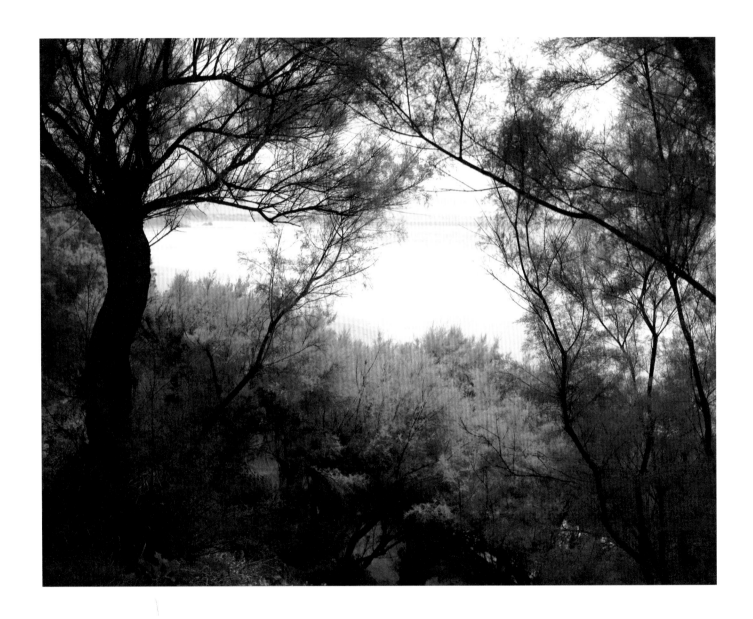

Atlantic Beach 2007
C-print 100cm x 125cm

Mike Marshall

IKON

Museum and Art Galleries, Paisley

Foreword

There is a beguiling modesty in Mike Marshall's work overall, a tendency towards wonderful understatement, that is its strength. We are impressed paradoxically by a lack of dramatic moment, by a seemingly easy-going-ness, by an avoidance of limelight. What could be less theatrical than *Someone Somewhere is Doing This* (1998), a video work extraordinary in its ordinariness, made by the artist as he was starting to break onto the London art scene. It depicts a moving surface of water, sunlight glistening on waves, against a soundtrack of humming. It is the kind of noise someone makes without thinking, drifting off into daydream, possibly to wind up somewhere miles away, before being called back eventually into a here and now. It is as hypnotic as its subject is unremarkable, absolutely engaging as we easily imagine ourselves being that someone, somewhere else.

Increasingly Marshall has been concerned with the evocative nature of sound. Sometimes it is the sound of his own voice; sometimes it is simple sounds sampled and recast electronically. Impossible to convey through the pages of this publication, of course, they enhance the effect of this artist's work, making it more poignant, more effective in the way it suggests epiphanies whereby we grasp truths much bigger than the ostensible event. The soundtrack for the video *Days Like These* (2002), for example, combines the rhythmic hissing of a lawn sprinkler with droning ambient music to convey profound disquiet. On the other hand, *Cloudburst* (2005), a sound installation without video, could not be more delightful in the way it conjures up the refreshing quality of a short shower of rain.

Other recent work, featured here, is tantalising through its ambiguity. Still and moving images of seemingly nothing much encourage us to look more closely. It is this sharpening of perception that makes Mike Marshall's work so distinct and rich in what it has to offer. Thus generous in a philosophical sense, the exhibition, in turn, is the result of much generous support, especially that of the Esmée Fairbairn Foundation, The British Council, Mites, and Pianissimo, without which this would not be possible. Above all, thanks to the artist, for his unique vision.

Jonathan Watkins
Director, Ikon, Birmingham

Andrea Kusel
Keeper of Art, Museum and Art Galleries, Paisley

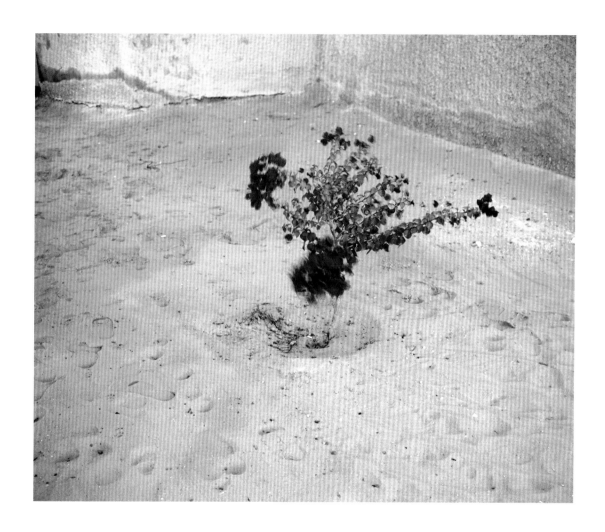

Bougainvillea 2003
C-print 91cm x 112cm

Notes on the Margins

1.

We live in space, in these spaces, these towns, this countryside, these corridors, these parks. That seems obvious to us. Perhaps indeed it should be obvious. But it isn't obvious.

Georges Perec, *Species of Spaces* (1974)

Here it comes again, that warm-toned, spectral, endlessly looping sequence. It is early morning. There is a shingle path, lit and shadowed by the feisty Andalucían sun, which leads from a doorway to the sands; we walk down that short trail, but we never reach the beach.

This is not a film by Mike Marshall. It is the author's earliest verifiable memory, dating back to when he was two years old. It's tempting to apply retrospective metaphor to it (for I'm sure I was alone, having briefly broken loose on a family holiday, and so this recollection might be said to summarise an idea of nascent independence, renegade questing) but to do so would also be dishonest. What I remember is simply the graphic light, the balmy air, those small stones grinding under my feet, and the sense that there was something desirable at the end of them. The ostensible object of my expedition, the beach, doesn't figure in this reverie.

Rarely can we predict when everyday experience is going to recompose itself miraculously and pass into indelible remembrance; and this somehow makes a mockery of the idea of videotaping 'events' (or at least assigns the results to a secondary order of importance). There is an established camcorder protocol: we point the lens at something that's *happening,* or a place of consensual interest: a wedding, the Grand Canyon, baby's first steps. If there is a journey, at its end we arrive somewhere: we don't tend to consider the passage as something worthwhile on its own. (This, of course, is an issue with broad cultural ramifications.) So I probably wouldn't have taped my Spanish stroll; not that, nor any of the inexplicable epiphanies of ambience that have followed it – those moments of feeling incontrovertibly invested in a reality anterior to language and our various other filtering mechanisms; moments we all experience and wish for more of. The circumscribed way we typically use our recording devices is connected, in a feedback loop, with how we perceive our world, which is implicitly hierarchical: this (most of us say) is potentially important and worthy of our precious time; that is not. In Marshall's art, those priorities find themselves upended. Technologies, played against type, elongate and distend the process of reception so that we move into a deeper, less complacent, and more physical relationship with what we see and hear.

A Place Not Far From Here (2005; filmed, like most of Marshall's moving-image productions, on video) rolls out a mere ten shots in nearly six minutes, collectively exploring various viewpoints from one position (albeit a mobile one; a swinging cane seat) in a sunlit garden apparently on the periphery of a forest. Stuck on its shaky perch, the camera peers forward, upward, downward. It scrutinises a shadowy tree-trunk, shimmering lattices of branches, their reflections on the dusty ground. The film is, in its own way, tightly and comprehensibly formal: it opens and closes with views of single trees, and at its precise midpoint is a quick horizontal tracking shot that turns branches into a green blur. Yet it is riven with ambiguities. The soundtrack entraps naturalistic noises (birdsong, crickets, a creaking that one takes to be the chair but that sounds suspiciously metallic) within a tentatively musical structure of keening, scraping notes, an intermittent, pitched-down percussive rhythm which suggests a jungle tom-tom, and Marshall's own glossolalia – tentative sibilance and vowel sounds which suggest language on the verge of articulation. And if, meanwhile, the camera is suspended, then signification is too. Despite being given visual fabric aplenty (an excess, we might say, considering how uncoordinated and hard-to-encompass it all is) we don't know where on earth we are. A house, glimpsed in the background, says these aren't the wilds of the jungle; but it is unclear to what extent even the soundtrack's bed of localised sound is diegetic or constructed and, by extension, what country this is.

And we won't find out. Given that Marshall's artwork is a moveable feast, the title's suggestion can only be taken metaphorically, as a suggestion of the propinquity of such uninscribed territory. We're thrown back on our own resources, and these are subjective: viewers of a nervous cast of mind, for instance, might pick up certain visual and sonic hints that this is a scene of foreign horror, an execution by hanging, while others less sensitive to sound or less prone to physical insecurity might consider it a fairly bucolic reverie. Either way the reading feels provisional and open to contravention. We can't quite find the words for it (and Marshall refuses to give them to us; in *What If Things Were Different* (2003), he pointedly does the opposite by reciting loaded, disdainful adjectives over footage of ponds swirling with dirt and protozoa: we might take issue with these terms, but they're there to keep us looking). Accordingly, we're unable to deploy a mediating shorthand that undermines the complicated quiddity of what we're experiencing, filing it tidily in the mind as a familiar typology. For such a low-key piece of work, *A Place Not Far From Here* is actually pretty brutalising in its compound unmooring of surety. Cruel to be kind, we might say. One thing can be clearly ascertained, however, and this is what the camera is *doing*: it's surveying a localised physical space. Quite literally, the "place not far from here" is proximal life itself.

2.

"Some people say not to worry 'bout the air / Some people never had experience with air…"
Talking Heads, *Air* (1979)

Days Like These (2002), in which Marshall trains his video camera on garden sprinklers watering abundantly plush greenery, is characteristically economical and balanced. While the montage toggles methodically between vantages on the machines' unassuming toil, the soundtrack – whose dominance underlines our openness to manipulation – offers a springy mix of the irrigators' machine-gun clatter, major-key synthesizer motifs, and an irregular two-note descending riff that distantly echoes John Williams' famous soundtrack for *Jaws*. (Dry humour often lurks ingratiatingly near the surface of Marshall's work.) The sprinklers, operating with seeming independence, come to appear estranged, mysterious: they appear by turns to emblematise civilised calm and to aggressively police the environment. Everything advanced above, about the mobilising of the viewer's agency, the deployment of doubt, and the merits of applying the camera's lingering gaze to the 'wrong' subject, applies again here.

Note, however, the specificity underlying Marshall's iconographic selection of sprinklers. For what they *do* is analogous to the activity of his camera (or anyone's conscious eye). Each jet of water they arc out measures, with some degree of empiricism, the span between one object and another: it cuts the air and clarifies that the air is there, terminating where it hits something. There's a lot of emphasis on the air in Marshall's art. What it argues, through the auspices of its variable media and subject matter, is that our environment isn't comprised merely of consensually interesting items punctuated by blank intervals. It is continuous, crammed with significant molecules, changeable – and all potentially remarkable, provided one's perceptual capacities are not choked by the bindweed of inertial habit.

In *Birdcatcher* (2006), the camera tracks over a forest floor. At first the mind is focused on accommodating the film's single, steadily progressing, slow-motion tracking shot to the title, which might lead us to anticipate an ornithological payoff. In time, as none seems about to materialise – and as the camera moves steadily closer to the ground – we're cued to slip from suspenseful anticipation to a less fraught present tense: the stymied eye comes to dwell interestedly on the changeability of the terrain (caterpillar-nibbled leaves studded with pink flowers, larger and more tangled weeds, igneous extrusions) sliding beneath the lens, its fauna waving strangely in the slowed breeze. But this too fades in turn: all kinds of cognitive shifts are possible, it appears, when one is stuck trying to get satisfaction from an artwork that

refuses to pander to our preconceptions. We begin to be distracted, even soothed, by the idea of moving in space itself, attuned to the position of the camera vis-à-vis the landscape and the strange sense of suspension and weightlessness that its movement inspires.

It is this – a sense of the alterable distance between us and the objects of our attention, and a sense of our movement through it – that our bodies remember, outweighing the common yet hard-to-recollect complexity of the landscape. One is left with this abstract sensation even though, relatively speaking, the film finally does get somewhere. Like *A Place Not Far From Here,* with which this film shares the distinction of being shot in wilderness on the fringe of civilisation (in this case a 100km sq rainforest that borders Bombay), *Birdcatcher* closes with a shot of a tree. One senses the cameraman rising, his head still dipped, as the lens moves up its spindly trunk before fading to black. That's no conclusion at all, really. (The screen darkens as the camera reveals that the trunk is bifurcated; if the artist were more of a symbolist, you might think he was objectifying the idea of an interpretative fork). But what it does is clarify Marshall's interest in the conventions of technological media and the assumptions we habitually bring to the table. And, connectedly, his allergy to letting narrative – one of various structural artifices that blinker direct experience – become the organising principle of his work: even when, as here, he toys with it in his title. In *Birdcatcher,* the notion of looking, really looking, becomes almost magical. It is hitched to an idea of flight.

While this film's soundtrack appears to replay the rich thrum of the forest, heightening our awareness of the moist jungle air in general by filling it with noise, it is actually carefully tweaked to give a sense of specific positionality. Ground-level frequencies were filtered in, and canopy-level noise cut out (i.e. more crickets, less birds), to approximate more closely the experience of being inches from to the green ground. When Marshall makes stand-alone audio pieces they tend to consider sound almost sculpturally, as something that constructs, defines, locates and fills space. His two sonic extravaganzas, *Cloud Burst* and *Birds Sing in Response to a Distant Calamity,* were each meticulously stitched together from samples of those arrhythmic natural phenomena and replayed through an encircling network of speakers to give audiences the idea that they were standing in, respectively, a rainstorm or an aviary. As with Marshall's films, medium-specific assumptions (here, that "natural-sounding" sound is necessarily natural) are routed and reversed in order to heighten and prolong awareness and deliver more substantial purchase on the content. Apparent verisimilitude – using the gallery as a laboratory to test the audience's response to something they would normally not listen closely to – gives way to a probing sense of doubt about the veracity of what is being experienced; this keeps us there,

listening, and leads finally to an impressive comprehension of the sheer sonic density of those natural ambiences which we customarily filter out.

Pin-drop conditions aren't necessarily required. Marshall replayed the naturalistic *The Sound of Bombay (a place not unlike this)* (2004), an ambient recording from a terrace in a Mumbai gallery, on the ostensibly similar terrace in Tate St Ives – thereby engendering all kinds of overlaps and discrepancies between the sounds of gulls in both places, the bi-continental bustle of lunching, and background musics. In such circumstances we don't just use our auditory faculties but are made aware that we are listening, just as in Marshall's visual art what's most important – beyond the specificity of the thing depicted – is that we're made conscious of the process of seeing.

3.

"We do not always proclaim loudly the most important thing we have to say."

Walter Benjamin, *The Image of Proust* (1929)

Marshall's photographs, like his films, bring centre stage that which would normally inhabit the edge, or be left out altogether. Here full rein is given to the implication, sometimes only inferred in his videos and sound pieces, that under certain perceptual circumstances what appears to be not much can become *too* much. But the distractions his films offer, usually in terms of camera movement, are denied: it is the viewer and the image, the viewer and its quiet attendant difficulty. Go ahead and try to memorise, say, *Grass* (2003), a seemingly offhand study of pale gold grasses rising up from mulchy wetland, fringed with slender white flowers. In detail, this scene doesn't adhere to the brainpan. As often in Marshall's photographs, something grips the eye in an abstract fashion – the central region is bright, fading and darkening towards the edges – but there are no mnemonic keys, no organising architecture. My optical memory of *Grass* is hazy: a dream of rich colour, which borders on being beautiful despite (or because of?) the quotidian subject. This, my rebuffed sensors say, is a picture of some grass, no more and no less; I can't turn it into a symbol of something else.

But it takes time to get to that point. And in that interval something has sunk in, so that I do come away with a strong memory of *something*: my own tussle with this obdurate, seemingly insignificant but actually garrulously excessive patch of reality, which, in order to defend myself from its uninscribed excess, I've wanted to convert into a chassis for an idea. In engaging

me while refusing that – in illuminating the conventions that characterise my own etiquette of viewing, and thereby limit what I'll pay attention to – *Grass* has functioned not so much visually as affectively. It revealed its habit-shaking purpose, really, when as I finally turned away from it, feeling as if the effort had been for naught, and yet departing, though not with an afterimage, with a dense knot of feeling: an affective residue.

Technologies, and the ways in which we think and look while engaged with them, engineer subjectivities, they shape our systems of vision: a point Marshall made when, in *Train Passing Through Trees* (2005), he counterposed the process of filming with the movement of a train, thereby coupling two Victorian vehicles for seeing the world in a new way. When we pick up a camera, we go looking for something to photograph, something worth photographing. This, declare Marshall's photographs of that which we ignore, is a tendency that stops us from actually looking at the fullness of our surroundings even after we put the camera down. And when we look at photographs, our expectations are no less rigid; in an image such as *Sloping Bank with Fence* (2005) – a tilted, washed-out view of a gradient catching detritus in its tangle of weeds and furze – Marshall plays them like a harp. Something of this order has crept into English paintings before, but rarely: isolate the brackish foreground of Constable's *Salisbury Cathedral, from the Meadows* (1831), and we're close to what Marshall is chasing here, and a painting such as Stanley Spencer's *Gypsophila* (1933), a fairly formless mass of shrubs and vegetables in a vicarage garden, is closer still, mirroring Marshall's use of a hot centre to give preconscious anchorage to a variegated spread of apparent insignificant abundance; but Spencer, a mystic Christian, saw all nature as holy. Beyond such outcrops, this is a tradition of vision – and a challenge to entrenched practices of perception – that barely exists.

Not obviously animated by a belief system, Marshall's art frequently plays on a fear of meaninglessness: the "horror of the contingent" Jean-Paul Sartre famously anatomised in *Nausea* (1938). There is a redemptive quality to Marshall's handling of this trope, however, since we might discern in his photographs a kind of safety zone for dealing with such existential vertigo. It's notable that his images usually deal with a limited, comprehensible, and proximal space: the foliage-lined stretch of what looks like a car park in *Gravel* (2003), for example, the grass-speckled waters and dark crumbling banks of *River* (2004) or the sun-dappled anonymity of *Driveway with Broken Branch* (2005). We're invited to send our eyes forward into these anomic shallows, to move gingerly around them and accept that nothing here is a stand-in for anything else (the presence of metaphor merely ensuring that we're not looking at the thing itself, but at whatever the physical object or space is a stand-in for).

But Marshall is evidently restless enough, and sufficiently sensitised to his audience's potential to accommodate themselves to such techniques, to be already effecting sidesteps. His photographs, now, aren't always direct redactions: recently, he's begun hand-tinting black-and-white images, reducing the colour palette and questioning naturalism in similar fashion to his constructed sound-works, his modified soundtracks, and his not-always-veracious films (*The Thunder and Lightning* (2006) interjects two fleeting shots of garden flowers not taken during the thunderstorm it documents). His photographs sometimes flirt with overdetermined symbolism, seemingly to show how much of an easier option it is. *Boats from a Cliff* (2004), for example: the camera's flash illuminating a small, scrubby patch of weedy land on a promontory's lip, overlooking a grey sea with a single ship riding in it. One must accept, given the trajectory of Marshall's practice, that this isn't the prologue to a suicide's leap, nor an analogy of margin-walking. It's an area of tangible space. And that's more than enough, if we can see it.

This isn't to deny that certain of Marshall's formal decisions are intended to mobilise or at least infer a broader thematic, one which might be summarised as an idea of emergence or of coming-into-being. There is evidence enough for this. Several of his videos have emphasised the play of light and shadow: the view of light-flecked water over which Marshall hums distractedly in *Someone Somewhere is Doing This* (1998); the shadows snapping into focus under cloud movements in *Sunlight* (2002); the geometric silhouettes transiently inscribed on empty seats in *Train Passing Through Trees,* and, obviously, *The Thunder and Lightning.* His photographs often tinker with depth of field, isolating some areas in focus and others in soft blur, while compositionally they often feature an aspect of the scene looming out of comparative darkness. The salient aspects of his soundtracks are picked out against the sort of dense background hiss of air which tends to be edited out of "professional" films. And, of course, in Marshall's videos the camera's movement makes the appearance of new facets of the physical scene inevitable.

At full extension, all these syntactical aspects can be considered to build towards a semaphoring of his project's deeper intent, which, in staging sustained encounters with supposedly discountable images and soundscapes that light up in stormy flashes our own perceptual tendencies, is to argue for and actively rehearse a less narrowband mode of perception – trusting it will migrate into muscle memory, as a complex sonata progressively inhabits a musician's central nervous system. "If everyday banality is so important," writes Gilles Deleuze in the course of analysing Italian neorealism in his exegesis of durational film-making, *Cinema 2* (1985), "it is because, being subject to sensory-motor schemata which are automatic and pre-established, it is all the more liable, on the least disturbance between

stimulus and response, suddenly to free itself from the laws of this schema and reveal itself in a visual and sound nakedness." Consider the subtle disturbances engendered by Marshall's scenarios as pathways to that insecure but richly oxygenated place. Someone somewhere is doing this. Not far from here. On days like these. What if things were different?

Martin Herbert

Someone Somewhere is Doing This 1998
Video for monitor with sound
DVD, 5 minutes

Light ripples on the surface of water to a soft and tuneless humming.

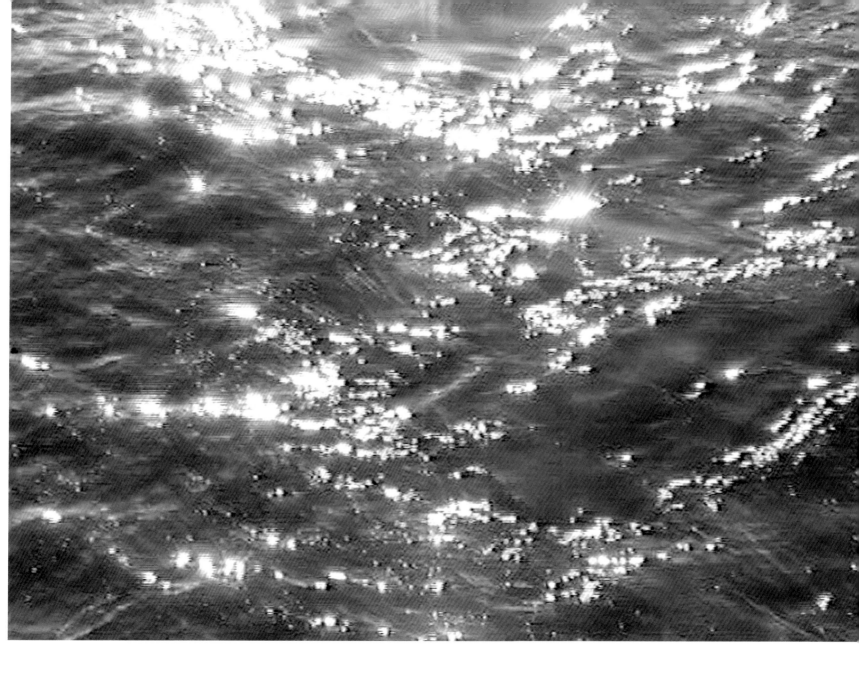

Days Like These 2003
Video projection with sound
DVD, 3 minutes 20 seconds

A sprinkler irrigates a summer garden. The ambient sounds of
the afternoon become part of a simple musical composition.

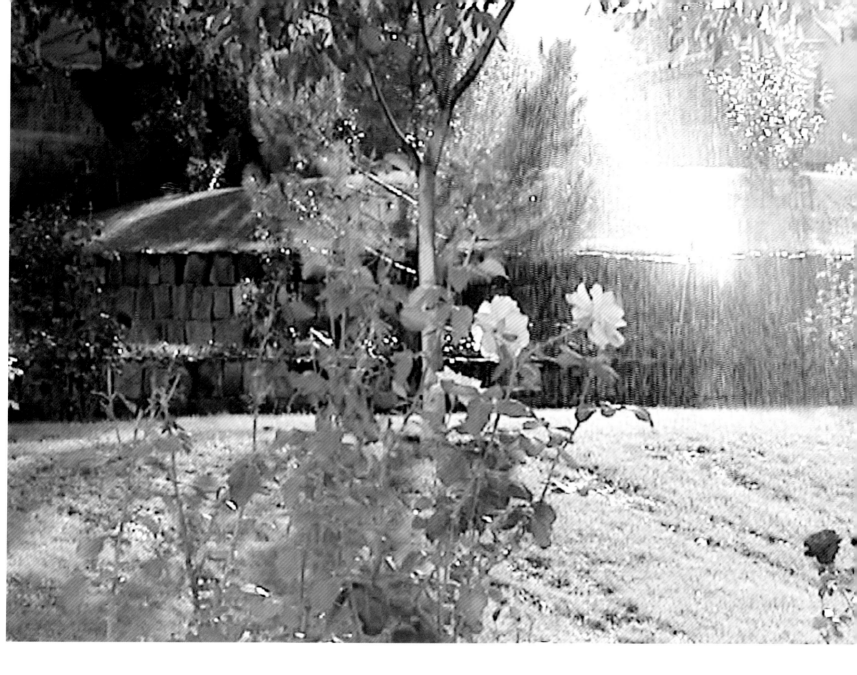

 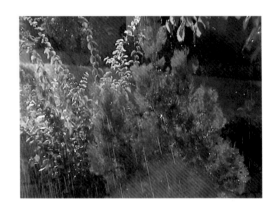

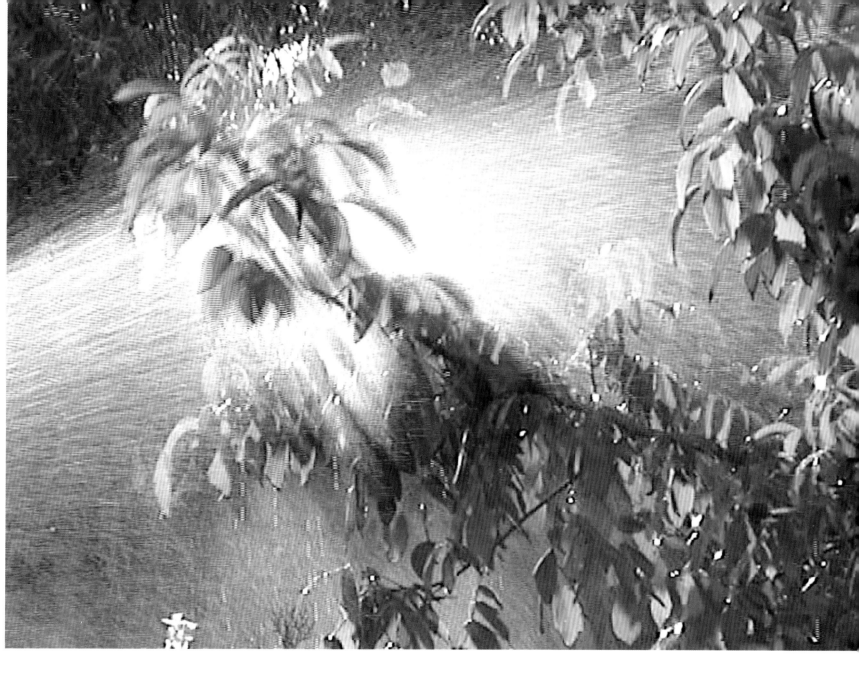

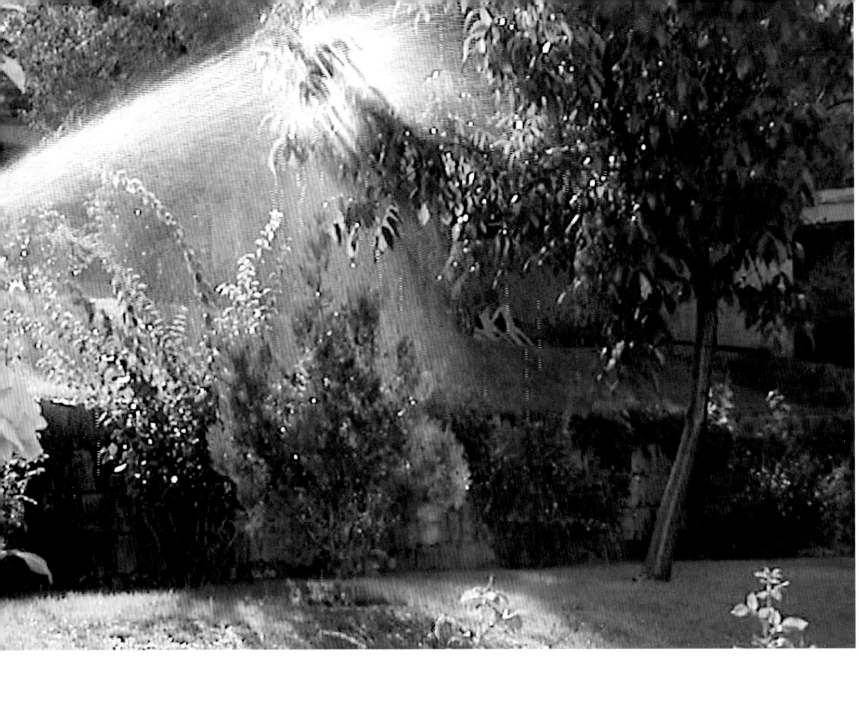

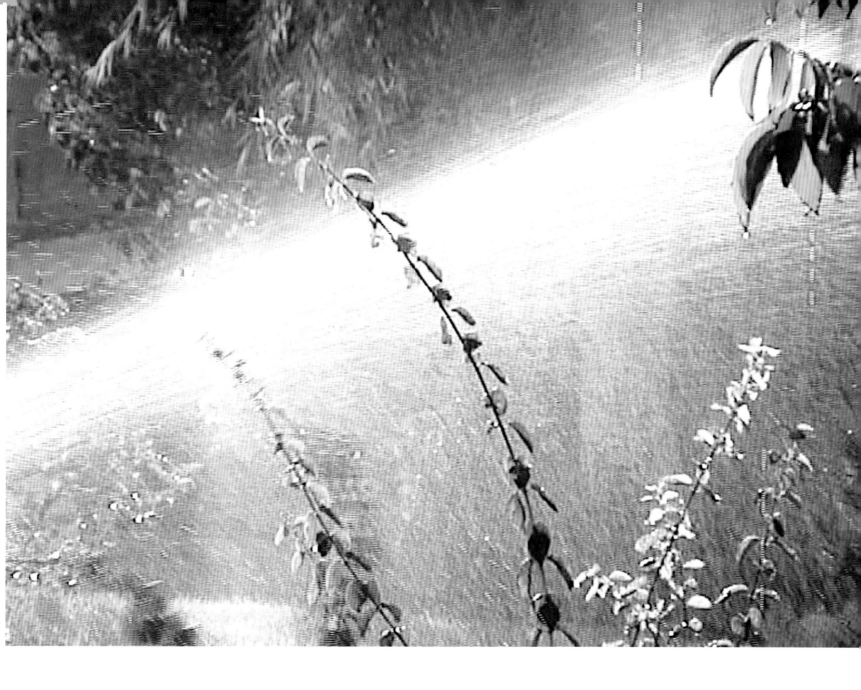

Hello hello hello hello

Goodbye goodbye goodbye goodbye

Yes yes yes yes

No no no no

Hello hello **Goodbye** hello goodbye hello goodbye hello **Yes** hello goodbye yes **No** Hello goodbye yes no hello goodbye yes no hello goodbye...

Exploring a Small Canyon 2003
Video for projection or monitor with sound
DVD, 3 minutes

A figure stands alone in a desert canyon. He shouts simple words and listens as echoes multiply and overlap forming their own contradictory dialogue.

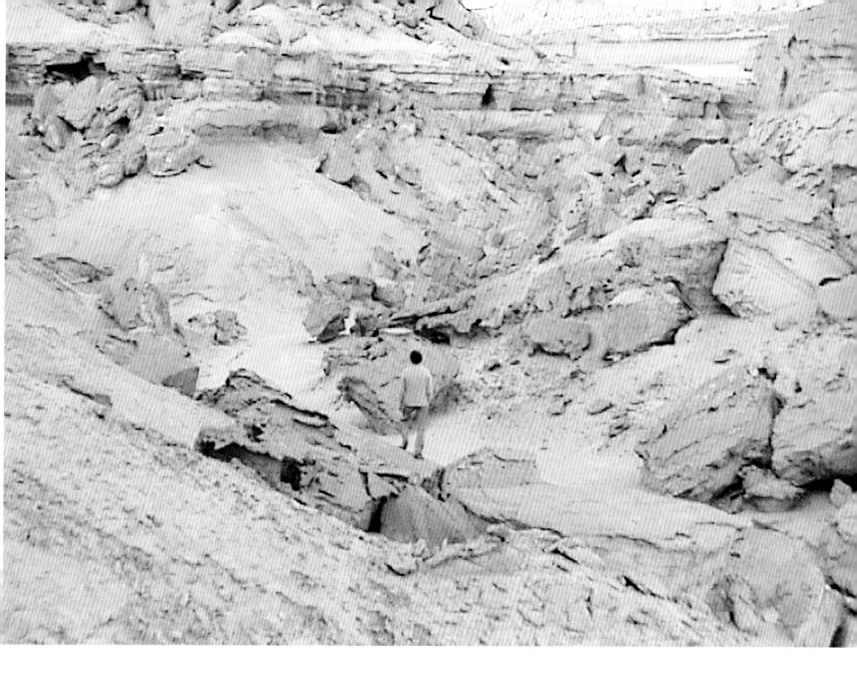

24

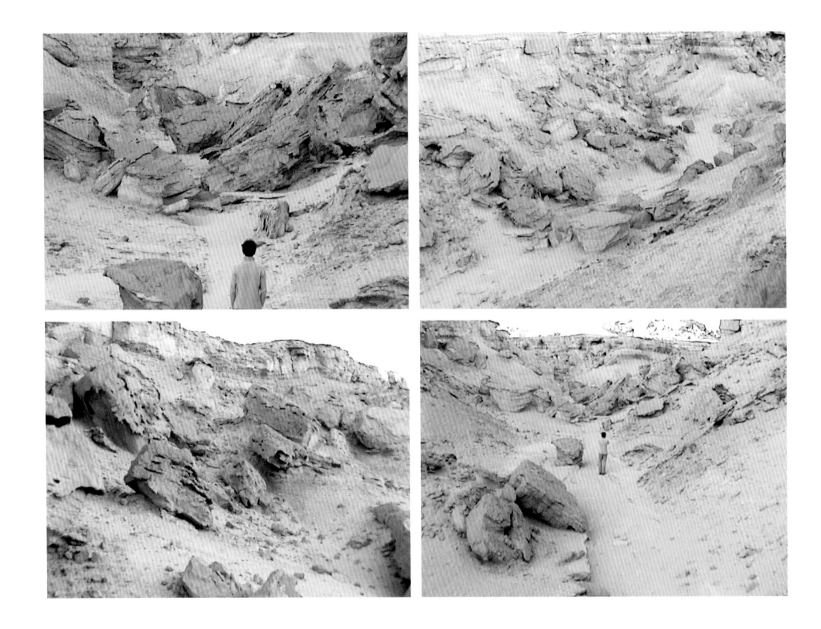

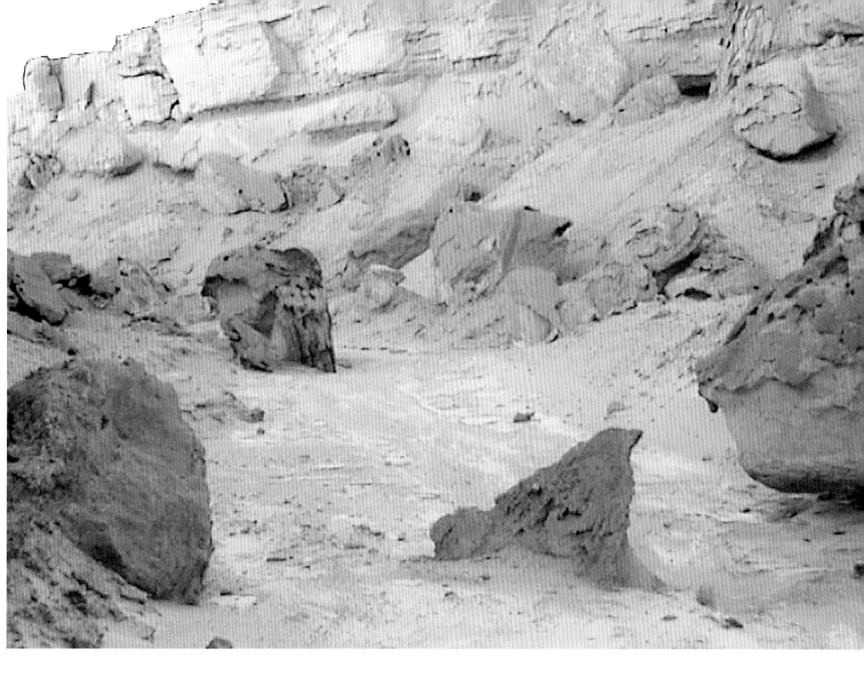

The Sound of Bombay 2004
Sound installation
Stereo CD, 20 minutes

A looped sound recording taken from the roof terrace of a public
art gallery in Bombay was installed on the roof terrace of the Tate
St Ives. The sounds of traffic, music, gulls, crows and distant voices
from Bombay overlap with the sounds of gulls, crows, sea and the
beach life of St Ives.

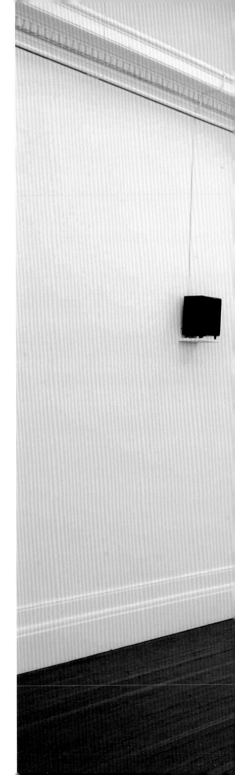

Birds Sing in Response to a Distant Calamity 2006
4.1 surround-sound installation
DVD, 12 minutes

A distant explosion triggers a variety of modulating and melodic
birdsong. The songs of the birds gradually quieten and fade until
triggered again by another explosion.

Chaffinch, Great Tit, Willow Warbler, Blackbird, Wren, Chiff Chaff,
Blue Tit, Songthrush, Grey Wagtail, Linnet, Hedge Sparrow, Woodlark,
Tree Pipit, Wood Warbler, Crested Lark, Winchat, Yellowhammer,
Blue Headed Wagtail, Waxwing, Sky Lark, Corn Bunting.

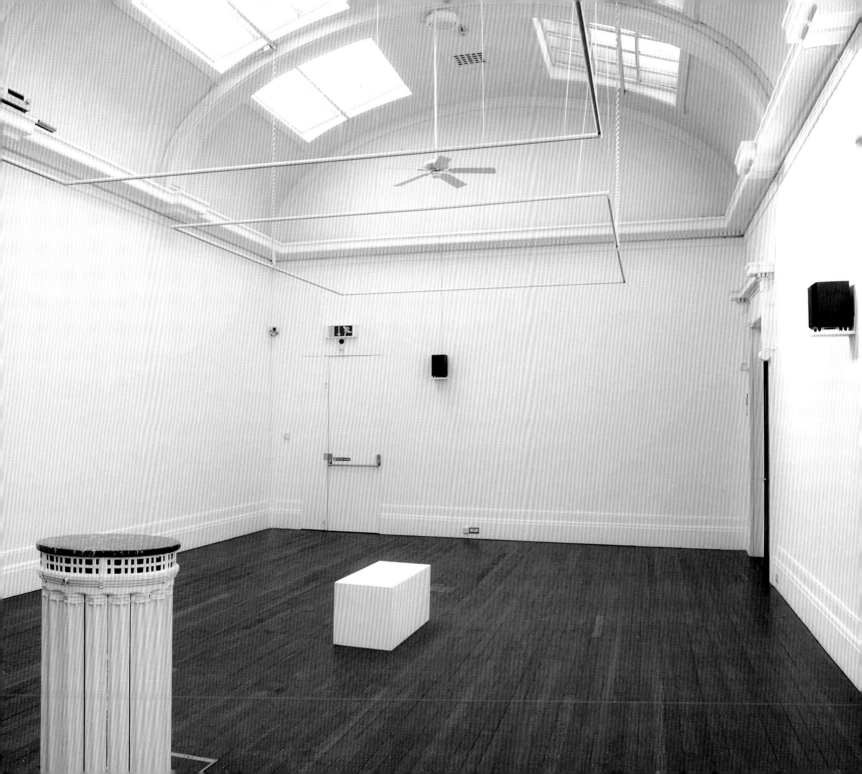

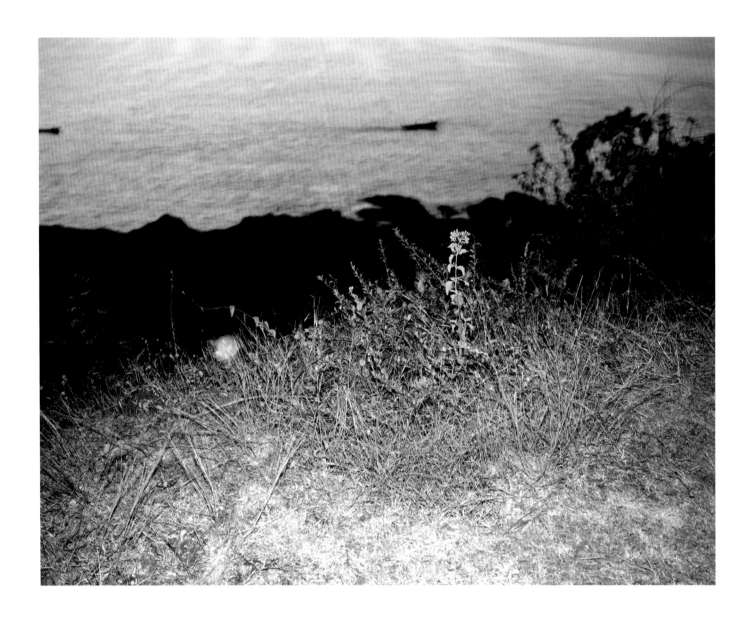

Boats from a Cliff 2004
C-print 95cm x 120cm

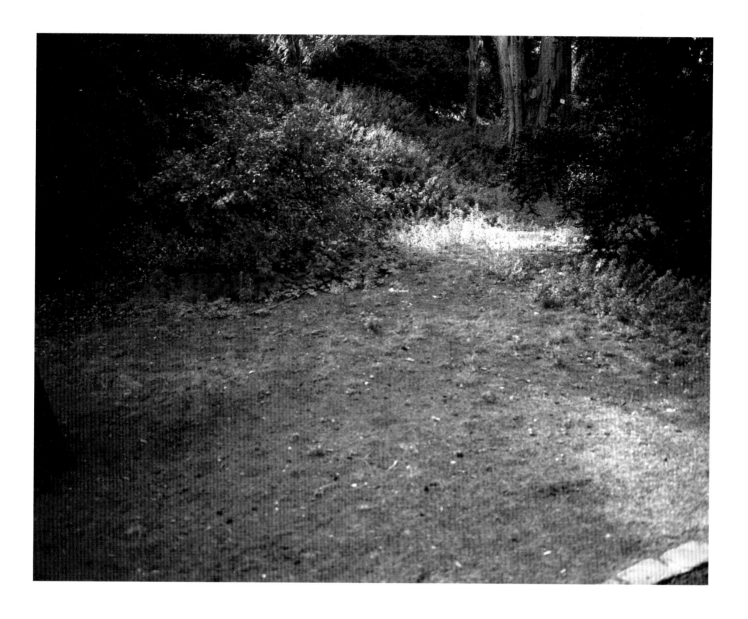

Footpath 2005
C-print 90cm x 114cm

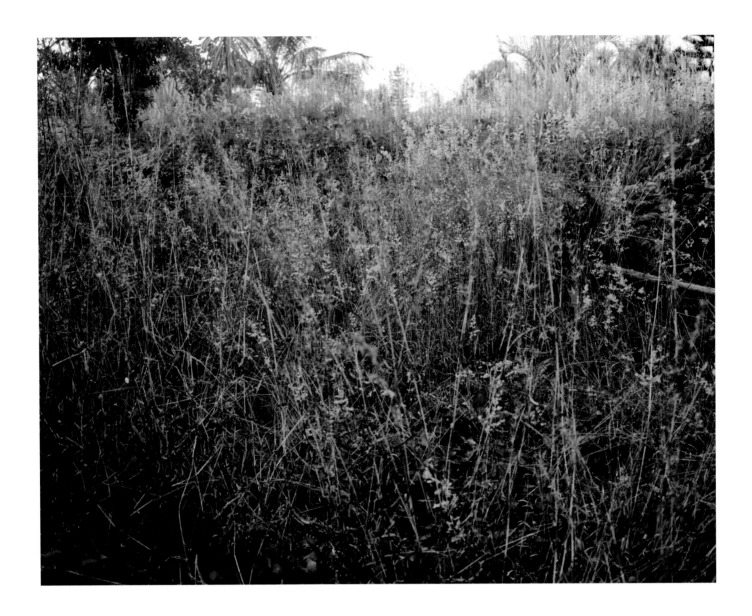

Grass and Flowers 2005
C-print 108cm x 136cm

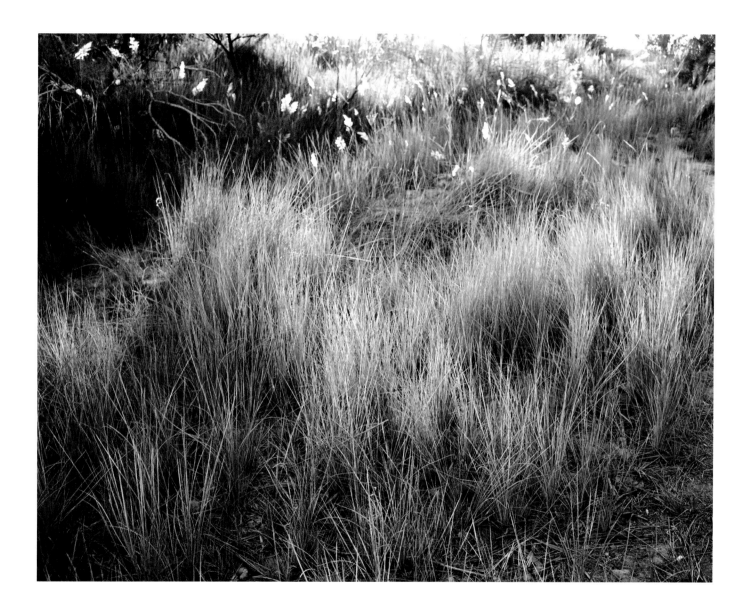

Grass 2003
C-print 108cm x 136cm

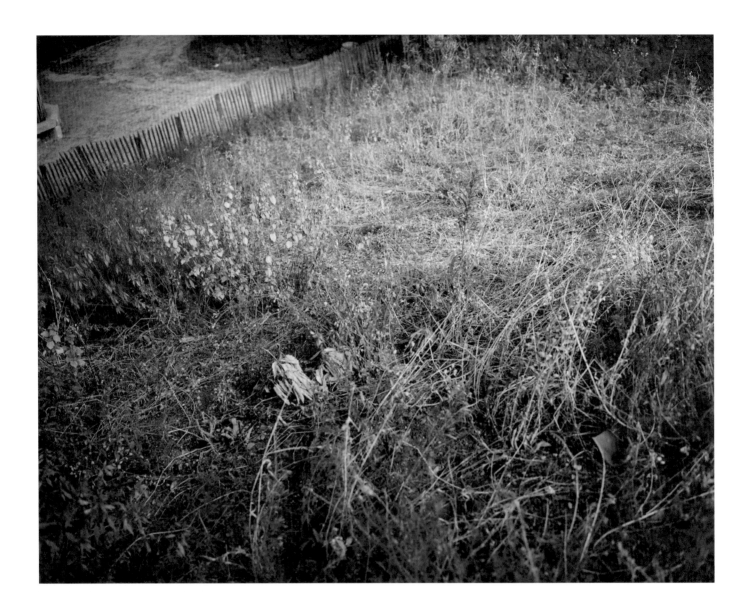

Sloping Bank with Fence 2005
C-print 118cm x 150cm

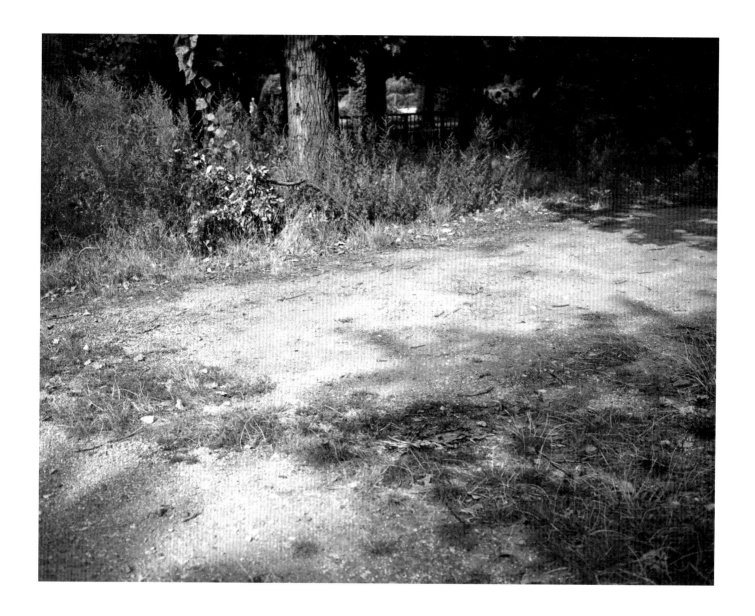

Driveway with Broken Branch 2005
C-print 110cm x 140cm

The Thunder and Lightning 2007
Video installation with 2.1 soundtrack
DVD, 8 minutes

Flashes of lightning in a shifting grey darkness momentarily illuminate
treetops, flowers and expanses of sky, to the sounds of thunder.

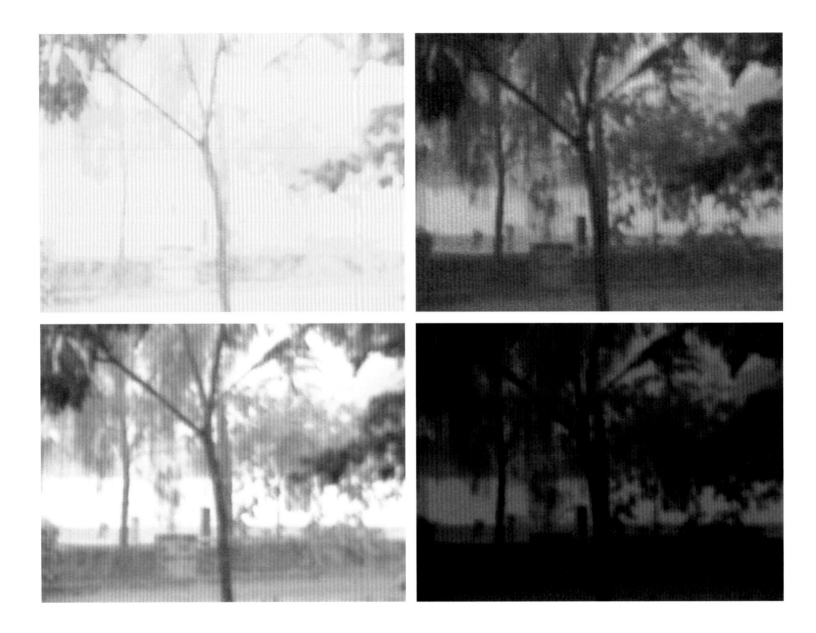

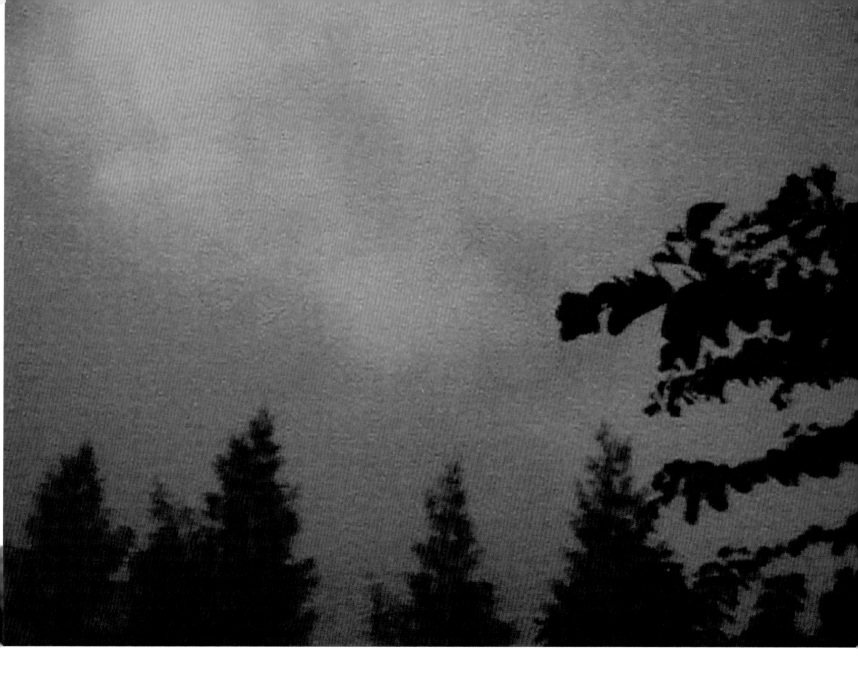

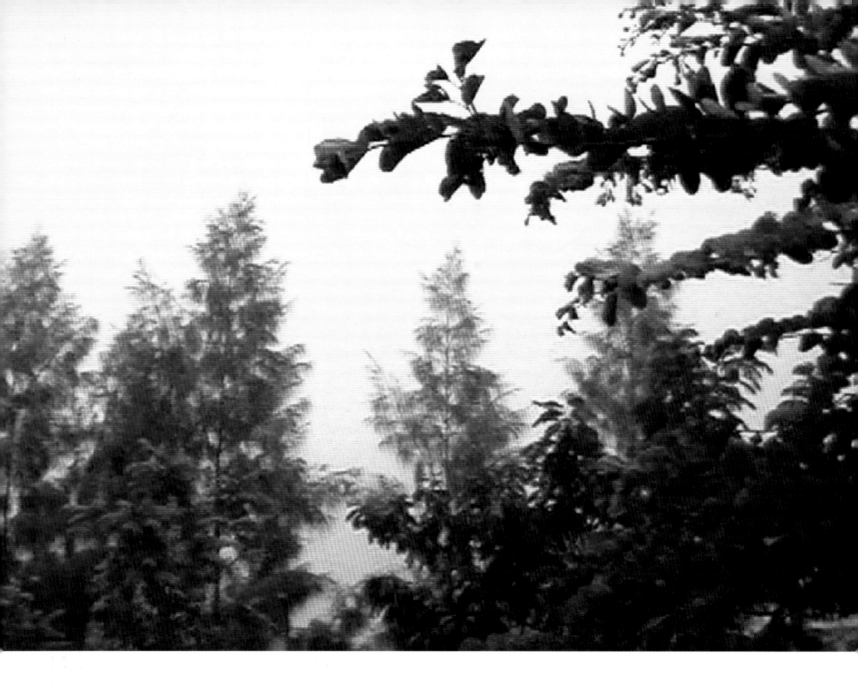

A Place Not Far From Here 2005
Video projection with sound
DVD, 5 minutes 40 seconds

Shot from a suspended chair swinging from a tree, the scene rocks
gently back and forth, at one point slowly rotating into a blur. A bass
note and whispers of half-uttered words punctuate the ambient sound.

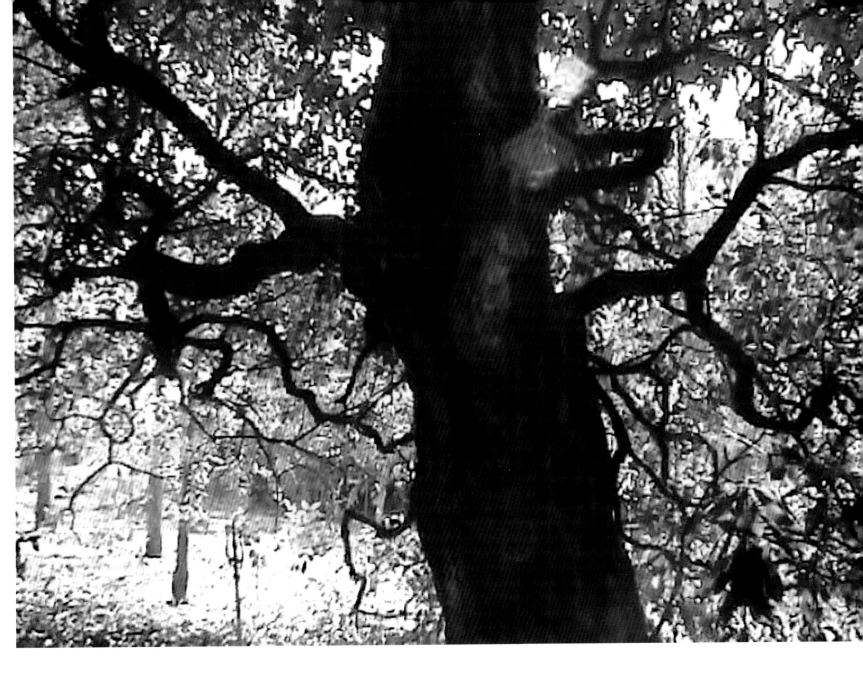

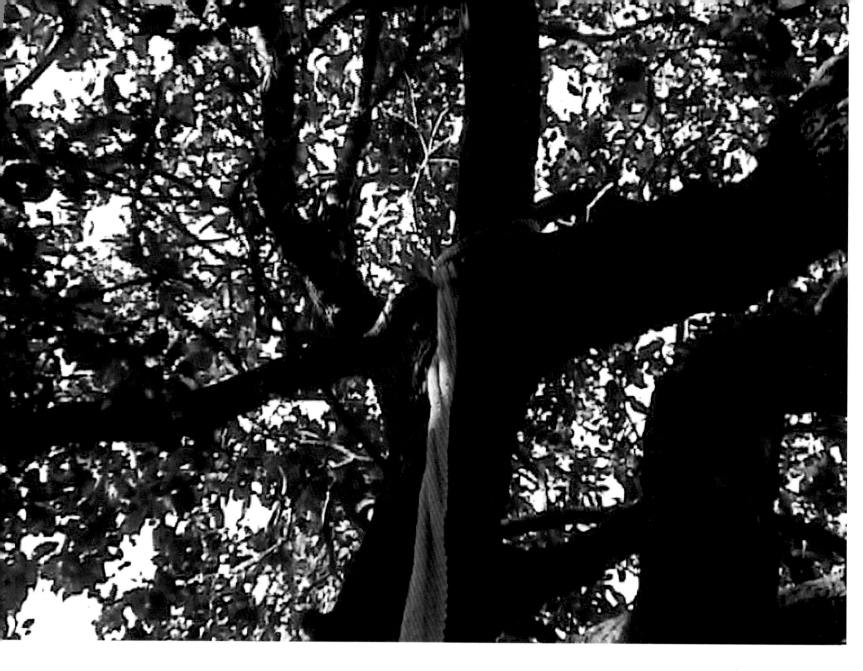

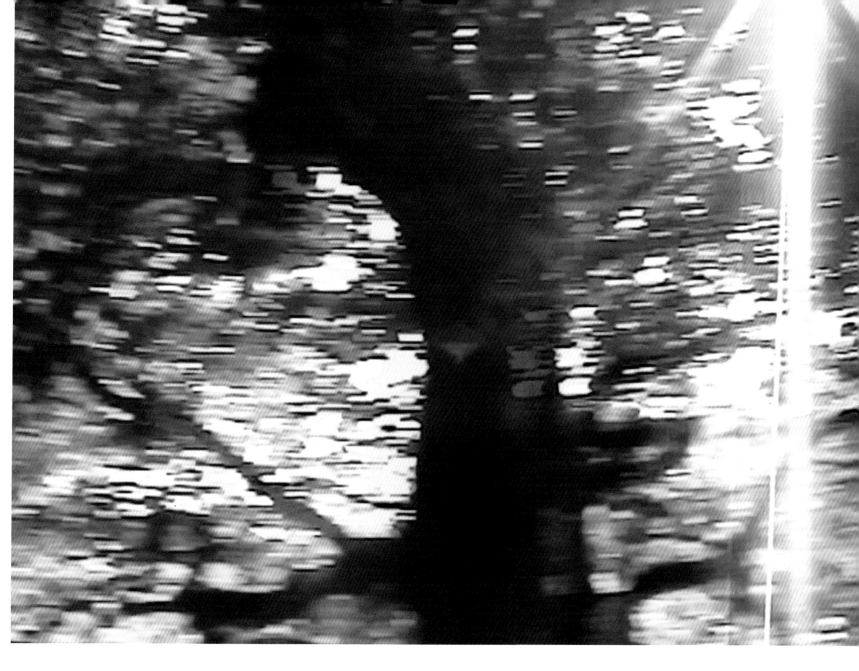

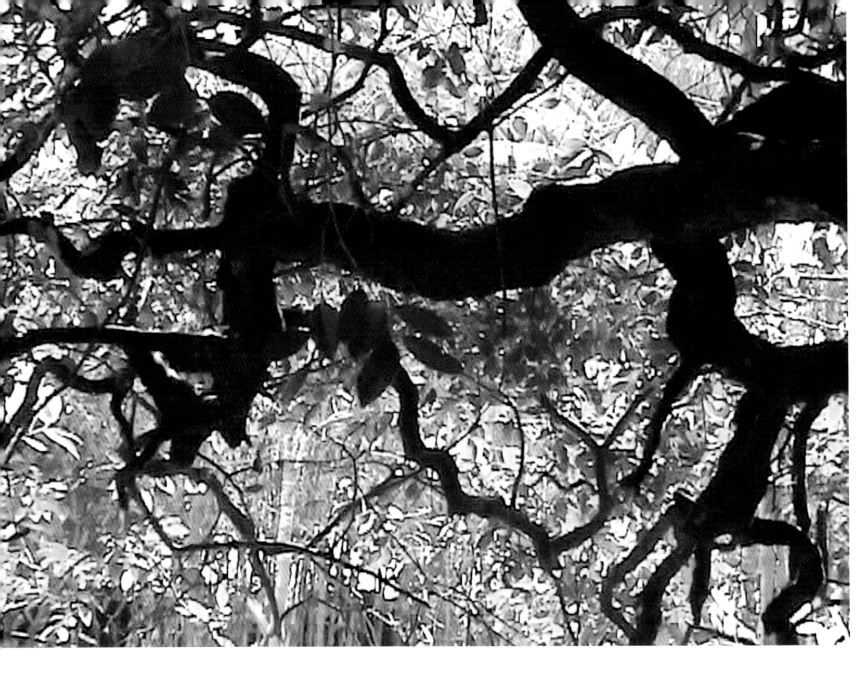

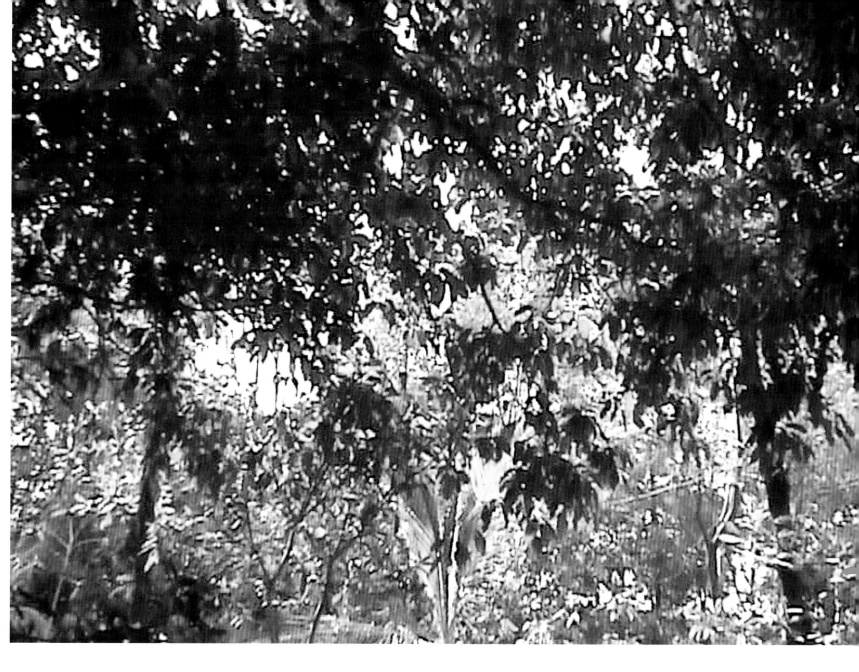

What if Things Were Different 2003
Video for monitor with sound
DVD, 3 minutes 30 seconds

In the irrigation canals of a desert oasis the water moves slowly by,
punctuated by a series of carefully articulated words.

**this stagnant foul soup rancid filth seething
cocktail fizzing stench vile detritus feeding
excreting putrid teeming fetid worlds**

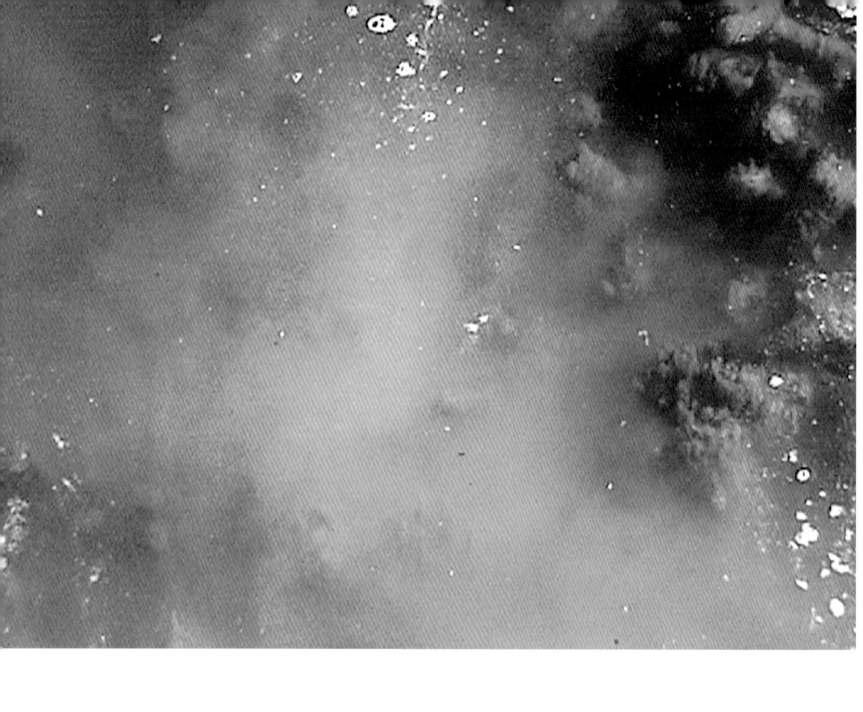

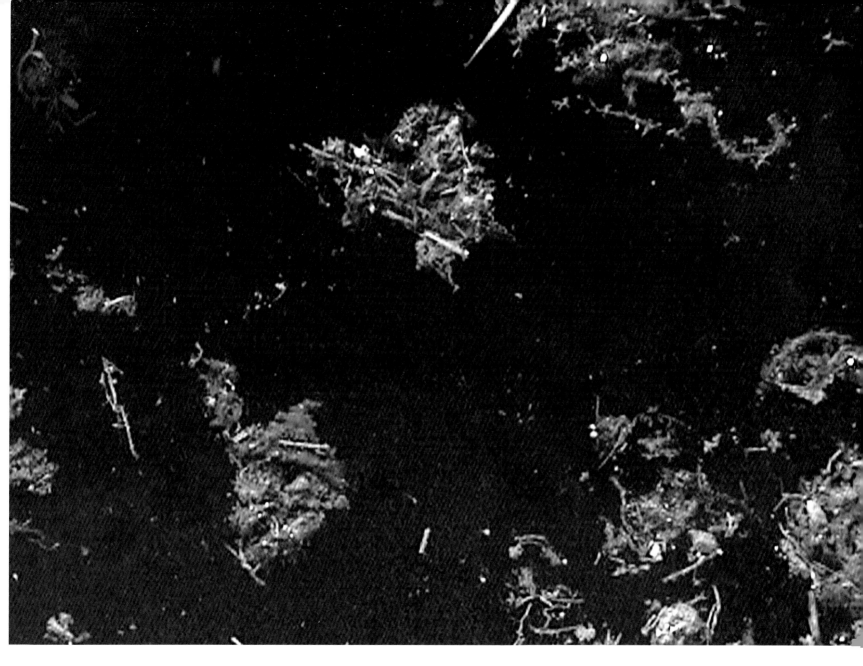

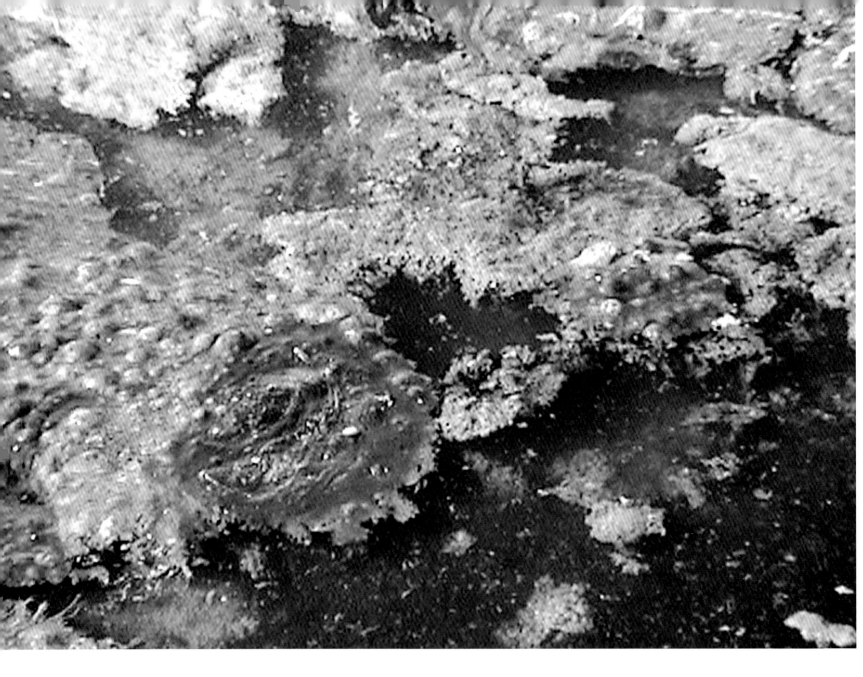

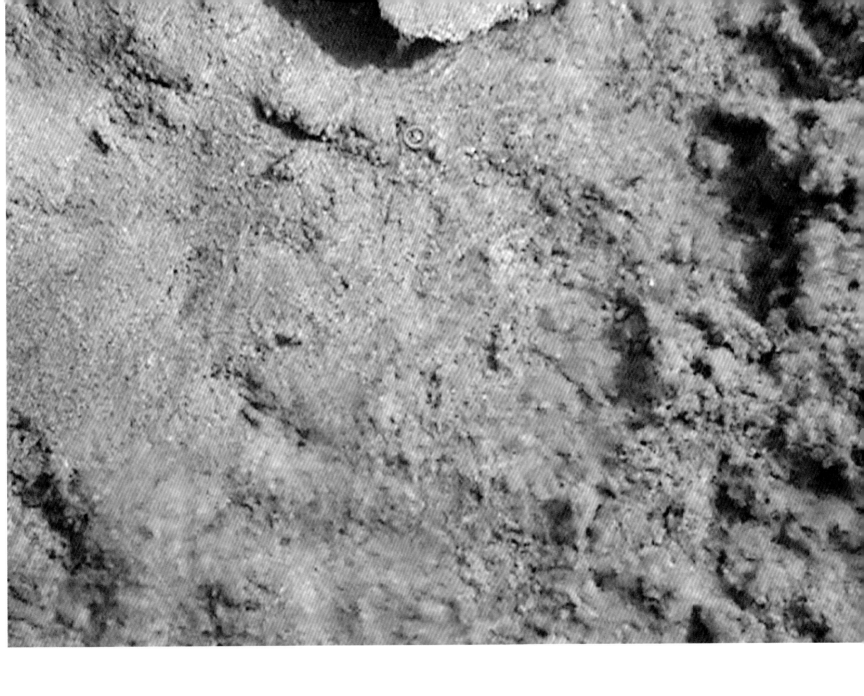

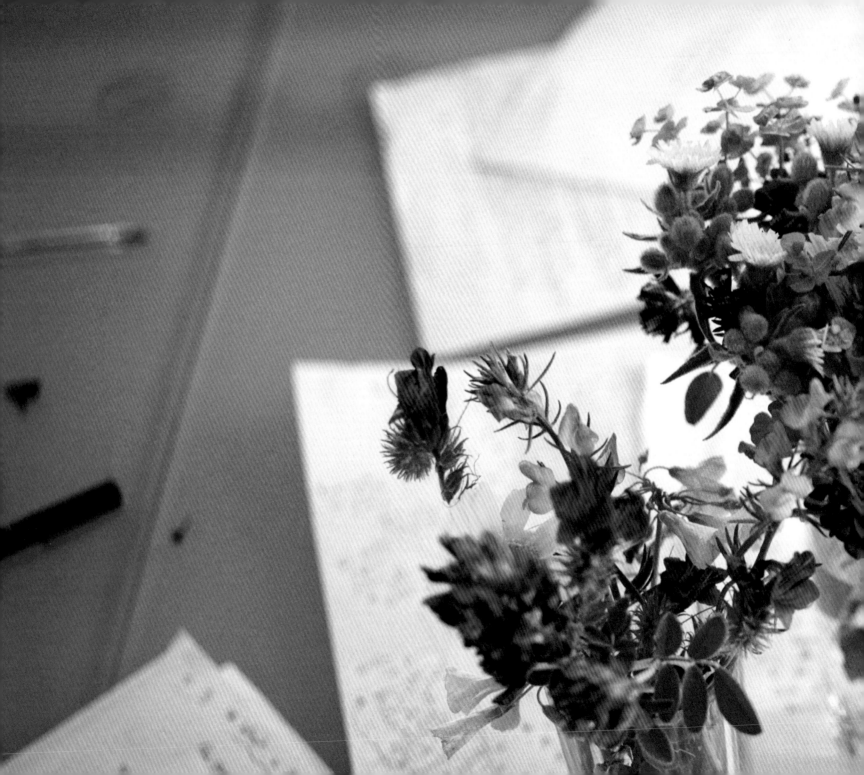

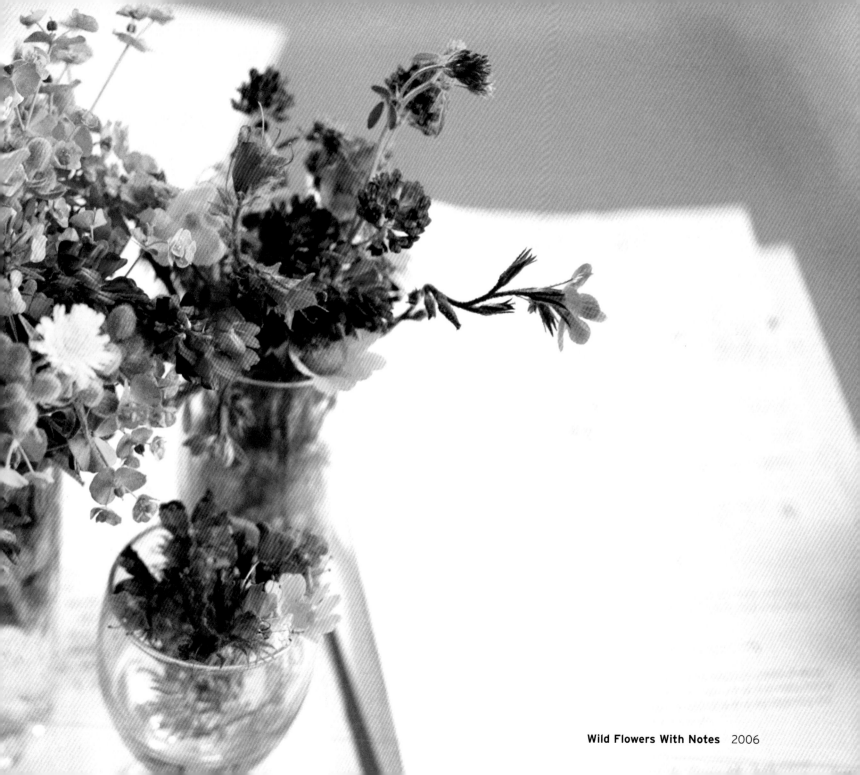

Wild Flowers With Notes 2006

Birdcatcher 2006
16mm colour film with sound transferred to DVD
5 minutes 37 seconds

A slow continuous tracking shot scans the undergrowth of a tropical
forest to a densely layered soundtrack of crickets and birdsong.

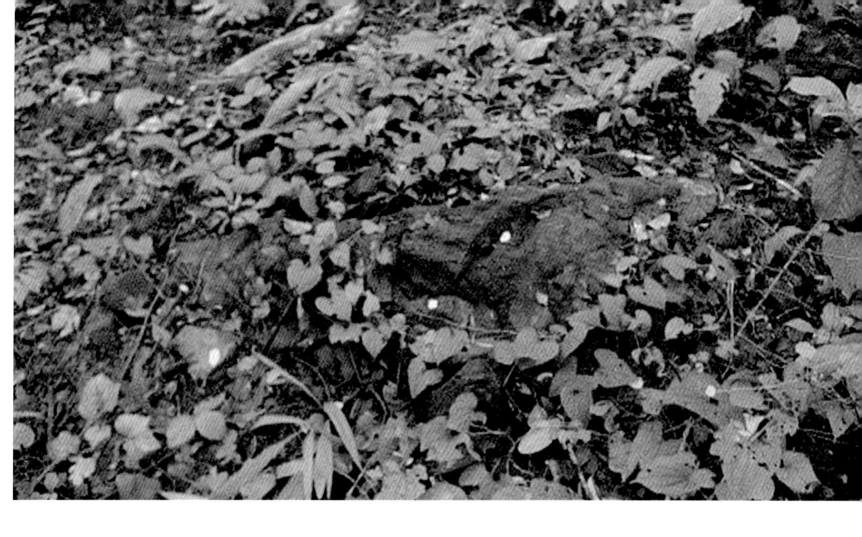

58

 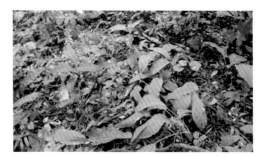 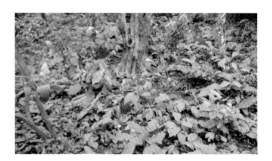

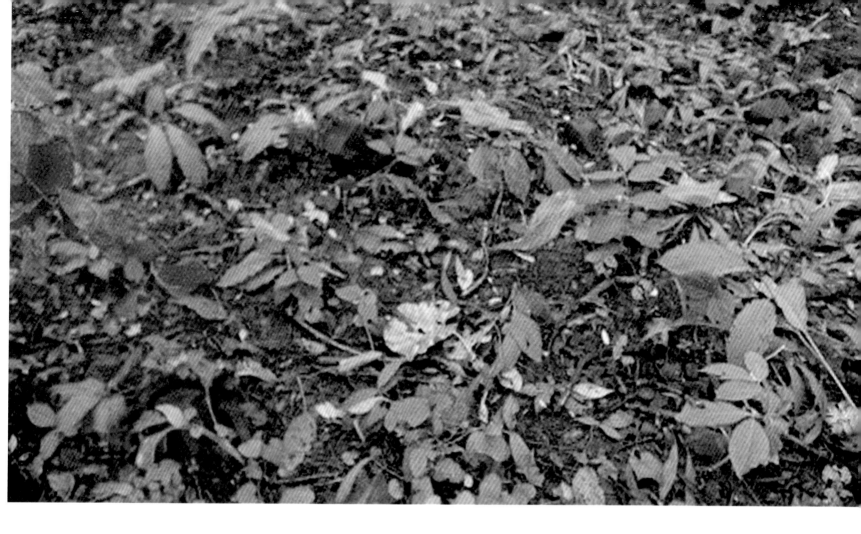

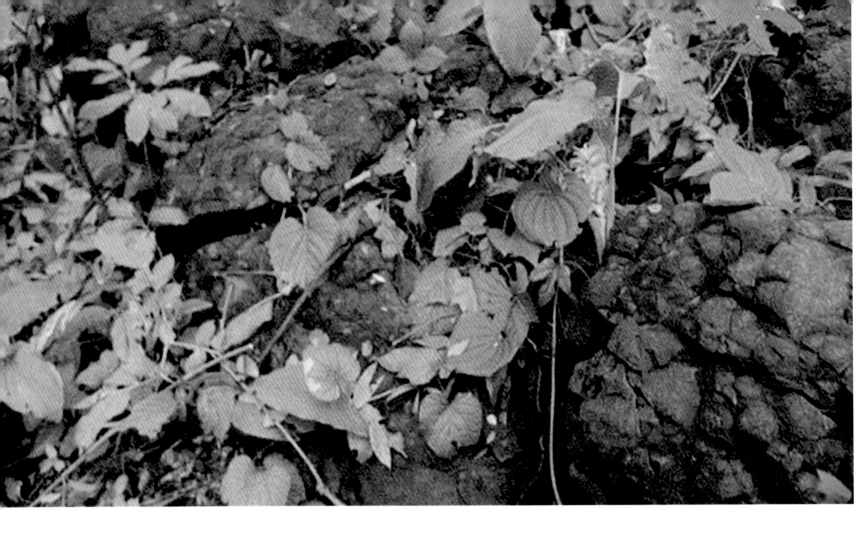

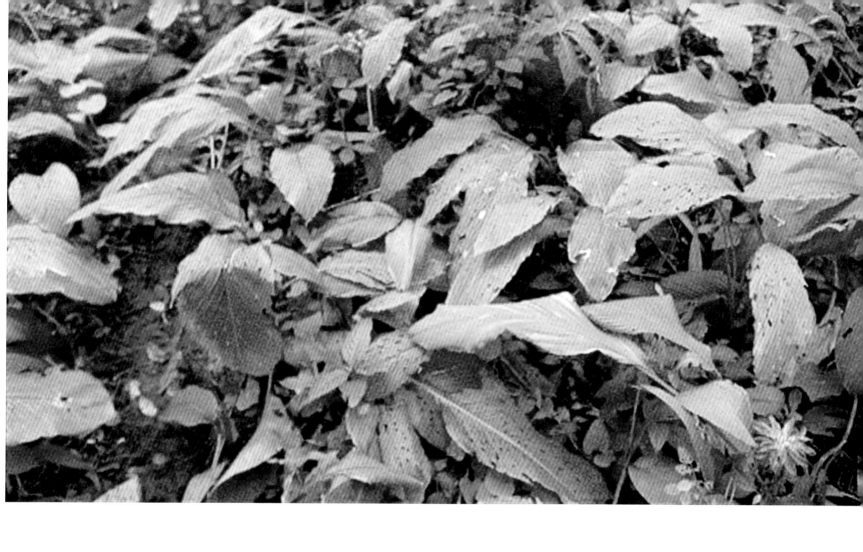

Sunlight 1999/2000
Video projection with sound
DVD, 6 minutes 35 seconds

The sun appears and disappears behind fast-moving clouds as
shadows abruptly transform a collection of mundane urban scenes.

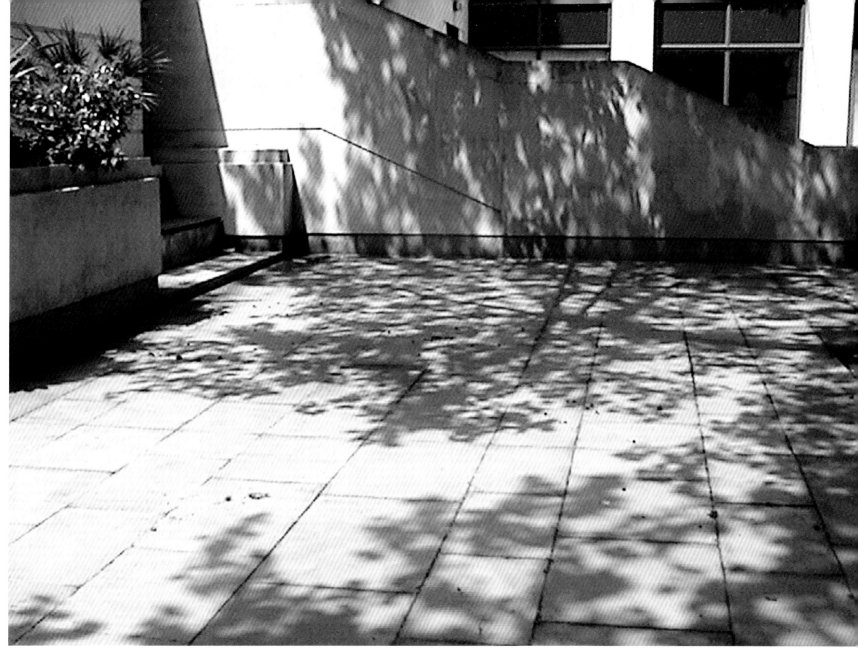

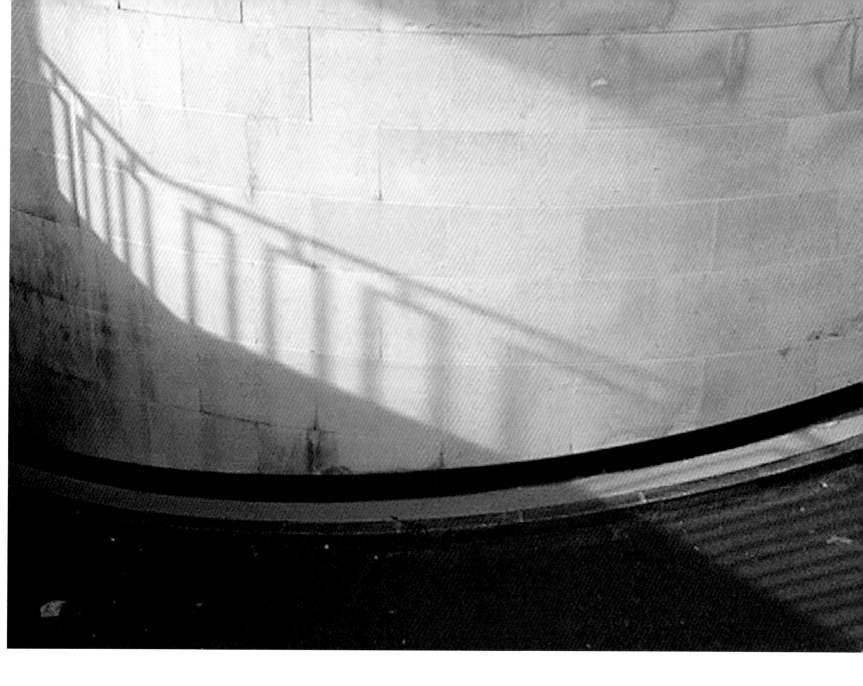

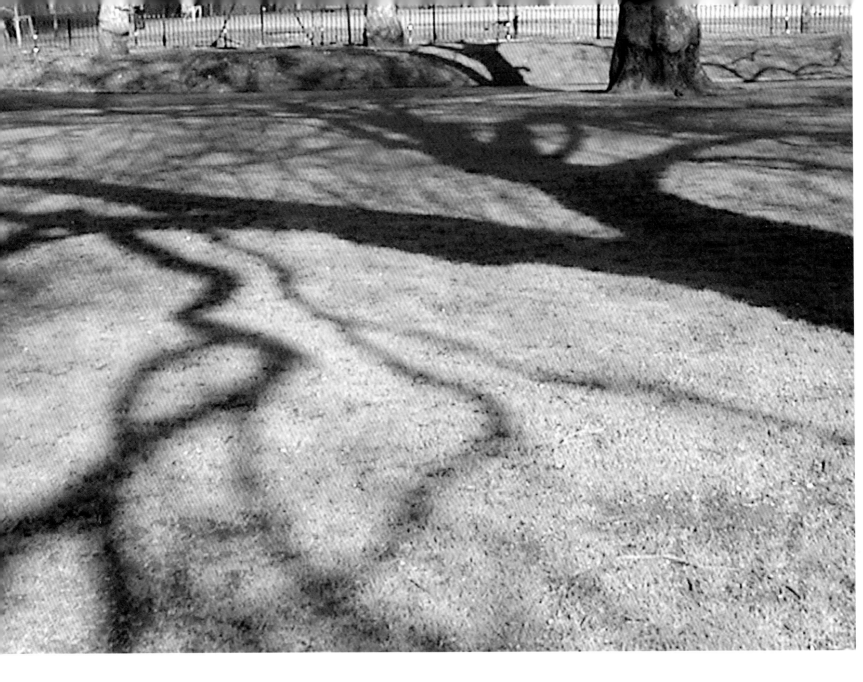

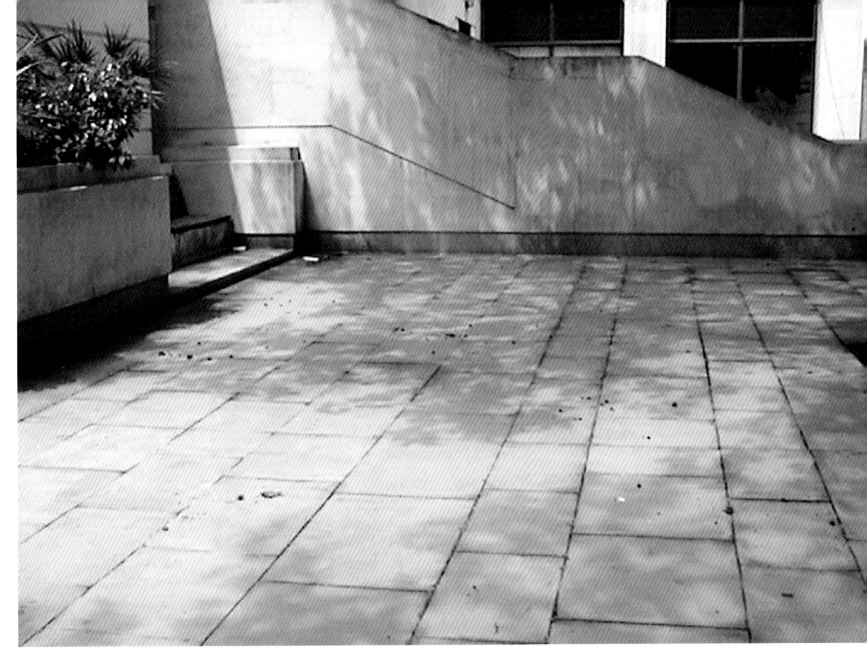

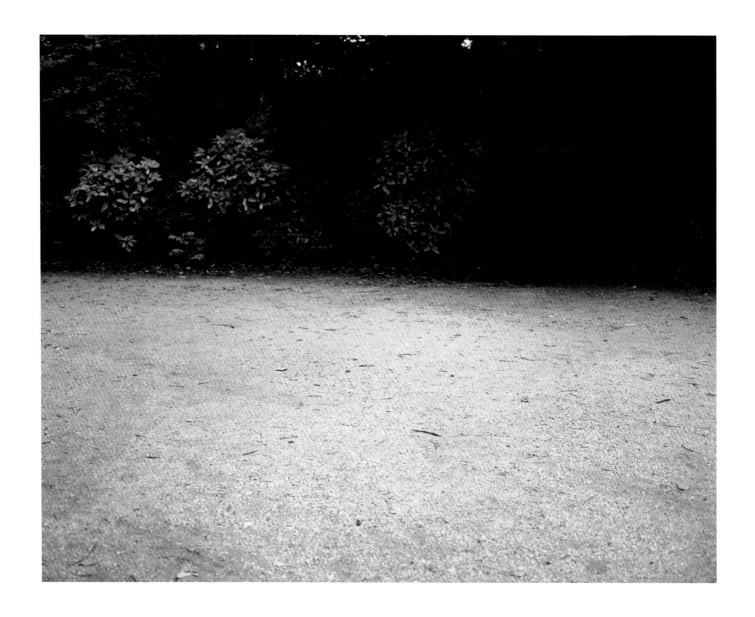

Gravel 2003
C-print 114cm x 147cm

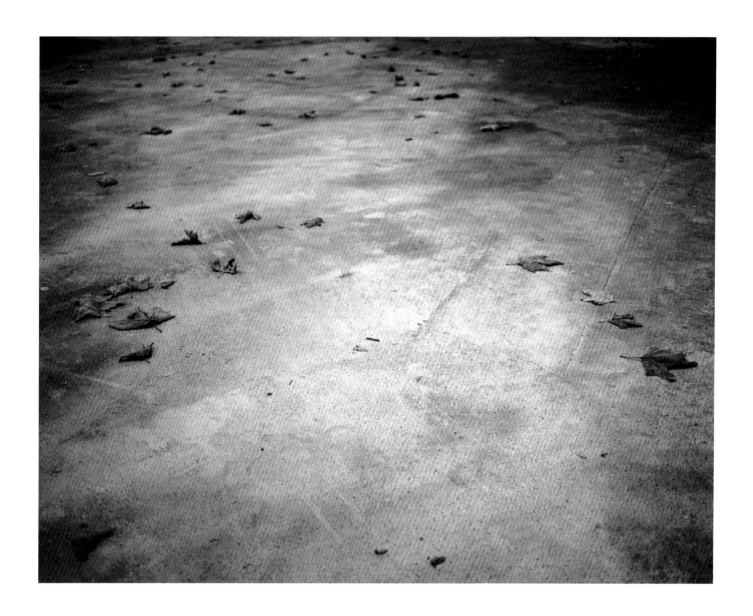

Concrete Pavement 2003
C-print 118cm x 160cm

Green Wall 2003
C-print 122cm x 158cm

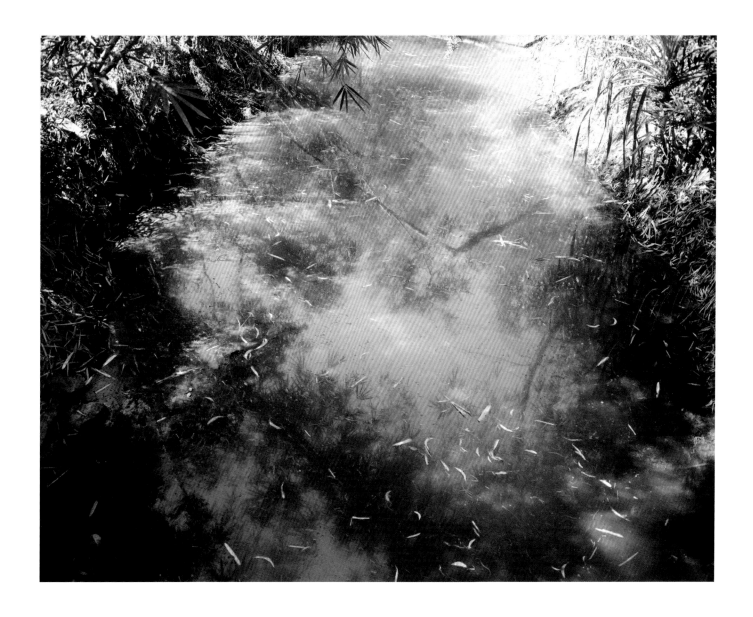

River 2004
C-print 122cm x 158cm

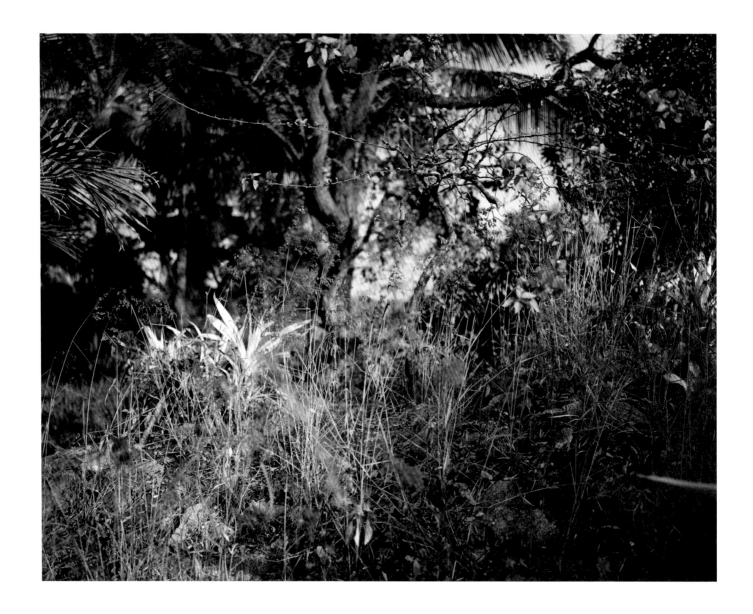

Front Garden II 2004
C-print 114cm x 147cm

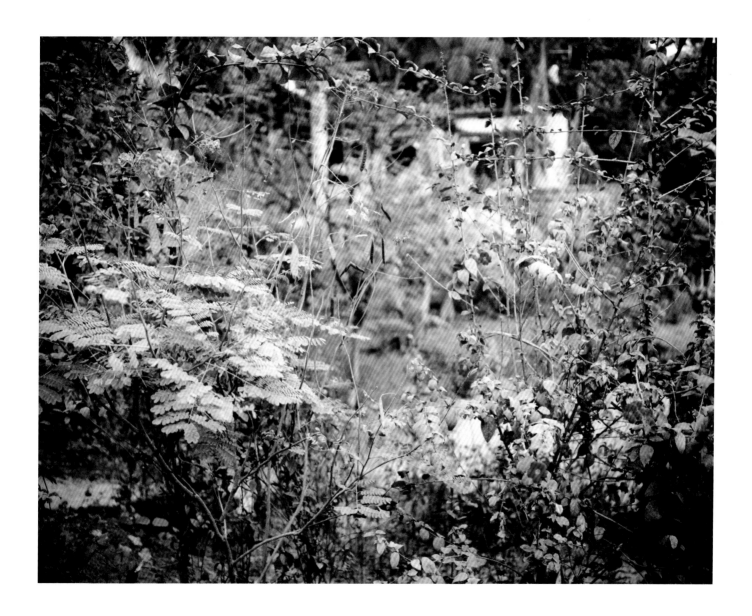

Front Garden I 2004
C-print 114cm x 147cm

Cloudburst 2005
Eight speaker surround-sound installation
Two synchronised DVDs, 4 minutes

Individual drops of water land on a variety of different surfaces – glass,
paper, concrete etc. Each droplet is carefully timed, layered and placed in
space. Around 200,000 drops fall in a period of four minutes, the sounds
slowly reaching a crescendo of multi-textured rain.

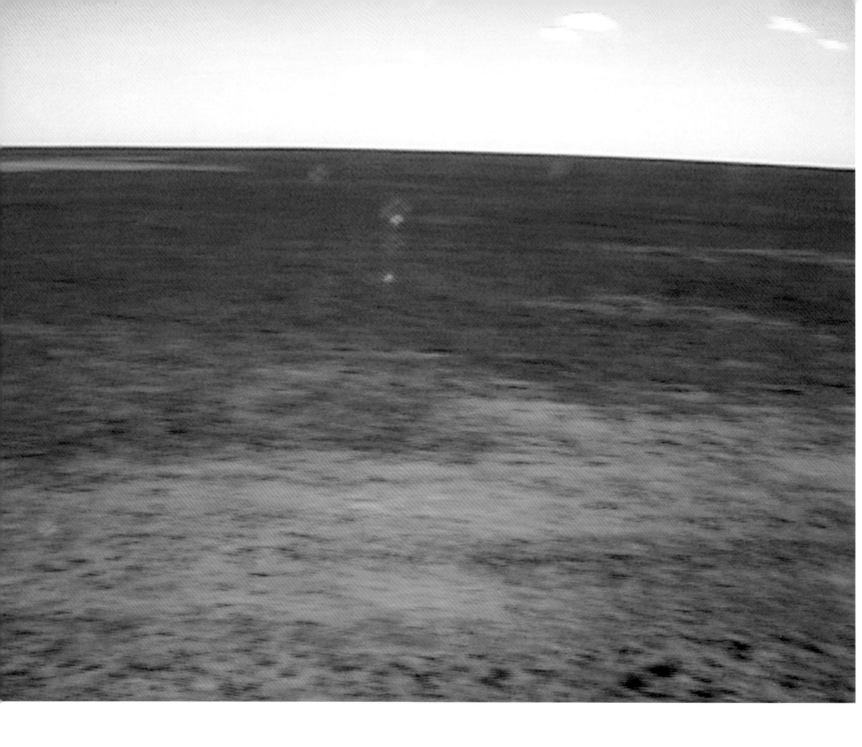

Why is six afraid of seven? Because seven ate nine. What do you call a fly with no wings? A walk. Why do cows have bells? Because their horns don't work. What's the difference between ignorance and apathy? I don't know and I don't care. What do you call a sheep with no legs? A cloud. Time flies like an arrow, but fruit flies like a banana. What goes black white, black white, black white? A penguin falling down the stairs. Why does Luke Skywalker know what you're getting for Christmas? Because he can feel your presence. What do you call a fish without an eye? A fsh. Why did the one-legged chicken cross the road? To get to the second-hand shop. Did you hear about the cross-eyed teacher? She couldn't control her pupils. Why did the tomato blush? Because he saw the salad dressing. What do you call a boomerang that doesn't come back? A stick. What's brown and sticky? A stick. Did you hear about the agnostic dyslexic insomniac? He lay awake at night wondering if there is a dog. Doctor I've just swallowed a pillow. How do you feel? A little down in the mouth. What do you get if you cross a thief with an orchestra? Robbery with violins. How many surrealists does it take to change a lightbulb? Fish. A policeman pulls over a driver. Would you blow into this bag for me sir? Why officer? Because my chips are too hot. What do you call a man with a wooden head? Edwood. What do you call a man with three wooden heads? Edwood wood wood. What do you call a man with four wooden heads? I don't know but Edwood wood wood would. Why don't blind people like sky-diving? Because it scares their dogs. What do you call a convertible Lada? A skip. Two cannibals are eating a clown, one cannibal says to the other cannibal, does this taste funny to you? What goes mark mark? A dog with a hair-lip. Why was the mushroom invited to the party? Because he was a fun-gi. A sausage walks into a bar and the barman says sorry sir but we don't serve food. Did you hear about the mystic who refused dental treatment? He wanted to transcend dental medication. What is half of infinity? Nity. Why don't lobsters share? Because they're shellfish. A man walks into a pet shop and asks for a wasp. But we don't sell wasps sir. Then why do you have one in the window. What do you call a woman

with one leg longer than the other? Eileen. What do you call a deer with no eyes? No idea. What do you call a deer with no eyes and no legs? Still no idea. Have you heard about the rude ghost? She goes bum in the night. Two parrots sitting on a perch, one parrot says to the other, can you smell fish? What has four legs is green, fuzzy and if it fell out of a tree it would kill you? A pool table. What do you call a donkey with three legs? A wonky. What do you call a dog with no legs? It doesn't matter he won't come anyway. How can you tell if a vampire's been smoking? Because of his coffin. Why do elephants paint there toenails red? So they can hide upside-down in cherry trees. What did one spider say to the other? Time's fun when you're having flies. A termite walks into a bar and asks, is the bar tender here? What's the smelliest thing in the world? An anchovy's bottom. What did Snow White say to the chemist when he lost her film? Someday my prints will come. What do you call a woodpecker without a beak? A head-banger. What's blue and white and hides in trees? A fridge in a denim jacket. What do you get when you cross a comedian with a pair of knickers? A jester draws. What did the Buddhist say to the hotdog seller? Make me one with everything. A man walks into a bar with a toad on his head and the barman says how did you get that? It started as a wart on my leg said the toad. Did you hear about the devil worshipping dyslexic? He sold his soul to Santa. What's got a big stomach and lives in the Himalayas? The abdominal snowman. Did you hear about the paranoid with low self-esteem? He thought no-one was out to get him. Why don't eggs like prison? Because they get beaten-up in custardy.

The Earth is Flat 2001
Video for monitor with sound
DVD, 9 minutes

A man holding a camera runs across a barren desert reciting jokes from memory.
When both he and the jokes finally stop the camera scans the empty horizon.

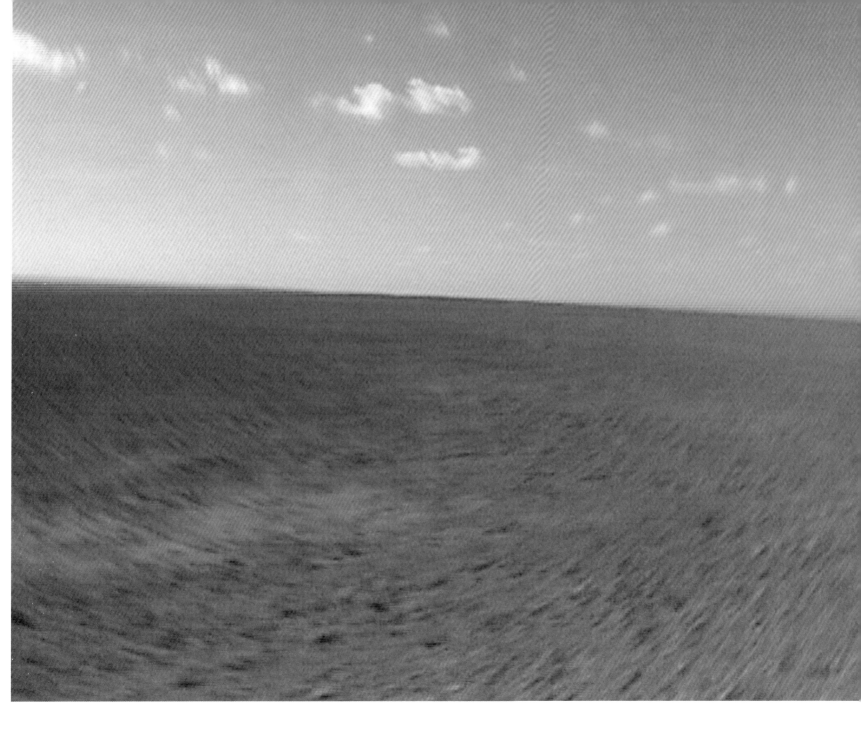

A Train Passes Through Trees 2005
Video projection with sound
DVD, 4 minutes 15 seconds

Light flickers inside a train carriage. Outside the landscape increasingly
dissolves into an abstraction of pulsating colour. The sound of a train's horn
can just be heard through the distortion of the wind.

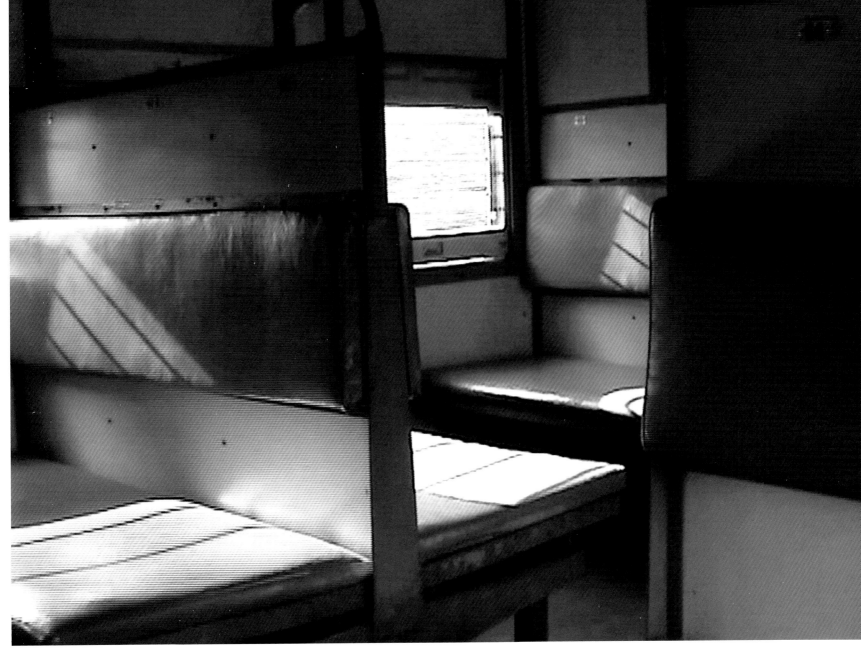

Daily Encounters

Showroom Cinema, Sheffield, 30 November 2005

Jaspar Joseph-Lester I want to start with what you described as the fullness of space. It's fascinating how you deal with this idea; it's as if the fullness of space and fullness of experience are joined within a single image. Although the videos are durational and the photos are static, there's a consistency of emptiness and fullness throughout. You spoke about the relationship of the large and small, there is something compact about the spaces in your work; they are spaces that seem to trap some element of experience without much happening. Through your talk it felt like the focus shifted to more of an observation, like a scientific enquiry of experience. Would you say more about this notion of the fullness of space?

Mike Marshall When I'm trying to take a photograph or make a video, it's as if I haven't worked out what, for instance, this glass (gestures) was before. I've worked out some activity of movement and I can touch the glass and pick it up to check it out; first, there is the idea that a space is already full, but also I want to place an activity there to test it. This could be shouting into space like in *Exploring a Small Canyon*, or using the movements provided by something else, like a train or the movement of water, or like the swing where I don't have to move the camera myself. It is an empirical enquiry, but it's as much about thought and taking recognition and checking it against observation and sensation. What I am attempting is an empirical enquiry that will always prove that I'm wrong rather than a scientific kind of empiricism that aims at truth.

Nick Stewart Why don't you use film? I ask because resolution seems to be an issue in your work, and seeing it blown up this much isn't what you want.

Mike Marshall With video, you can feel the texture of the medium, let's say. It also has noise of the medium – it's got a grain, especially with the swing video *Not Far From Here*. Obviously the technology is limited when it comes to movement and detail so you can see it visually breaking down. It gives a certain liquidity to the surface where the solidity of the image is vague, video can put a fizz on the surface that doesn't make you feel nostalgic, in the way

that the grain of film can do. If I were using film with that subject matter it might feel too poetic and nostalgic. I also use a still camera, but it doesn't produce the same nostalgia as a moving image might, or at least I don't think the photographs feel that nostalgic. Maybe nostalgia comes sometimes if you try to create something without subject matter, then people may see it as empty, and project backwards in time in an attempt to retrieve something that's missing or imagine that I'm implying darkness or the unknown, and something bad or sinister is going to happen. Basically, going from blank zero present, to either sinister future or going backwards in time to some Arcadian past. People will make up an interpretation and if I used film it would go backwards rather than forwards, so what I try to do is balance it somewhere in the middle, so I get a backwards and forwards, and I also get the stuff I'm interested in, which is around presence.

Nick Stewart Does language have any part in your work?

Mike Marshall Yes ... but accidentally, because even though I've never been that excited by language theory, I like it when words either lose their meaning or don't generate meaning when you connect them. Not that I want to come out with nonsense! I might be talking nonsense, but I don't want the work to be nonsense. If it has any kind of utterance, then it's blank or at the brink of saying something.

Jaspar Joseph-Lester You talk about the possibility of projecting something sinister that might be about to happen, and it seems that you were talking about its self-consciousness, going back to the medium, of being conscious of the surface, but at the same time being conscious of the way you perceive something. Does this self-awareness create an experience of strangeness? Many people describe your work as uncanny. In relation to the events that took place in the photographs and videos, does self-consciousness relate directly to a notion of strangeness?

Mike Marshall Maybe there's a tension when you create self-consciousness and that tension leads to discomfort for some. It is a mild discomfort, not that frightening. When I first showed *Not Far From Here*, two people said they'd found it relaxing, they'd watched it for ages; it was blissful, and they felt like they were on holiday. Then two others said it was the most horrific video they'd ever seen. I thought it was an exaggeration but they were actually saying they

thought it was the dying moments of somebody that had been hung by the neck. So you get these vast differences in interpretation, and I like to encourage that. Actually there's no reason to go that far in either direction, and this is why I try to bring it back to the texture of what's going on, constructing and deconstructing itself as an image and the suggestion of self-consciousness might help give an alternative to issues of the future and the past and of bad things about to happen.

Emma Cocker To extend the idea of readings and interpretations, I found some uneasy places and I'm probably one of those people who bring in horror references! With one work in particular – *Days Like These* – I couldn't stop thinking of *The Day of the Triffids*, with the clicking and animated nettles. Is it frustrating when people bring their interpretations?

Mike Marshall We're so preloaded in terms of how we read images from TV, cinema, *etc*. This is the thing about the uncanny again – we get it as a by-product of the fact that optics and cameras can look closely at things, closer than we do most of the time. The images they give us are intensified automatically, it's the world displaced in a way, so immediately you get the *Unheimlich*, the uncanny or the unhomely, just because it is looked at more carefully and differently. But I don't mind. What is difficult sometimes is when written material suggests in advance that it's sinister. If we are told in advance that it's sinister or creepy, or you're going to feel like this or that, then we may well feel uneasy and so somebody's subjective experience is given as a model in quite a prescriptive way.

Emma Cocker I'm interested in the way you use sound, which feels as though it borrows the language of uneasiness from other film sources.

Mike Marshall That's true; the bass definitely does. On the two videos where I used bass sound, I first constructed them without the bass and then thought they felt very light, but as soon as I put the bass on, it clicked. It creates a potential for the polarity immediately, and without that bass, it would become more anodyne and merely pleasurable, so I put it in to get balance.

Paul Haywood I'm interested in the same issue and the editing decisions that you take. When you show a rope, it's not the viewpoint of someone hanging from the rope, it's someone

else's viewpoint, and there's a suggestion that there could be someone hanging, but then you show part of the cane chair so we know that it's alright. Did you think about getting rid of those shots so you don't get the reassurance? That would make it more sinister, but you've chosen to include it.

Mike Marshall That's right, and during the talk I chose to tell you in advance that it was done swinging from a cane chair so I want you to know. I want it in the video because I don't want you to think that it's somebody hanging by the neck. I want the other interpretation, but some people miss it and do think it's somebody hanging by their neck. People miss shots, or if the videos are dream-like sometimes people don't notice things or they don't really interpret them. So I'm trying to get people to not grasp information in a tight and exact way and sometimes it succeeds and people don't, so they miss things that I actually want them to see as well.

Paul Haywood But you did choose to include that shot of the red rope, you could have cut that out and then that suggestion wouldn't have been there at all.

Mike Marshall I wanted it in there because I wanted people at least to have the opportunity to interpret it as swinging from a chair rather than hanging from a rope by the neck.

Horatio Eastwood I am interested in the way that you manipulate sound but leave the visuals as natural; I would have expected it the other way round. Viewers are becoming immune to Photoshop and CGI techniques, and I wonder if manipulating sound is a way of presenting us with something artificial.

Mike Marshall For most people, vision is a key sense, often overriding hearing, so we believe what we see before we believe what we hear. For example, when we hear a sound coming from the right, it might be because it's bounced off a wall on the right but originated from an actual event on the left, so spatial position and awareness of things is very doubtful when it comes to sound. In a way, sound is the reason why I like to make video because it's – going back to this glass again (gestures) or any object you see around you, you can look at an object and there's a certain definition, a certain certainty to it when you look at it at first glance. It's pretty much there – I can touch it – static, stable and fixed – at least it has the illusion of

being that way. Whereas what's happening with sound is that it's continually passing, forming and unforming. In a way, it's just that you can look at an object that seems relatively stable and hear sound that's completely fluid, relatively speaking, and it's enough reason to make a video alone. It's a way of keying into flux – it's not really about naturalism and construction, because construction is a natural process as much as the natural is a constructed process. They're both the same; I don't see one as more immediate; I don't rank one above the other in either realism or immediacy.

Horatio Eastwood To return to Paul and Emma's remarks, I am interested in the way you are filming. You seem to be working outside usual film and video language, because you're filming things that usually a person making a film wouldn't want to film, like the shadows that usually as a filmmaker you'd want to control. With these videos, people keep mentioning the sinister and I don't find this at all. I found the shadows very relaxing, reminding me of sunny days in a park. It's one of the few times you do see the shadows come and go, and you feel a sense of the earth's motion. I found the films really pleasurable.

Audience How far does making the familiar explicit go to giving spectators a greater under-standing of their relation with that familiar thing?

Mike Marshall It is partial, if anything. It's not really about the familiar; it's more about recognition and what we expect. You can make something familiar; that's as interesting as making something unfamiliar. It's as interesting either way, so rather than a question of familiar and unfamiliar it becomes a question of involvement, approach and attitude, and the techniques of how we approach things and the effects these techniques have on our understanding of the world.

Audience (same) Yes, the understanding of your surroundings.

Mike Marshall Some people get into it more than others, some people get nowhere with it, and some people say they now look at something a little differently, which is the best comment I can hope for.

Audience Parts of your work revolve around deconstruction and reconstruction of natural elements. What got you interested in this and what do you like about it?

Mike Marshall It's a by-product of what happens when you look at or listen to things. If you take any object and look at it long enough it starts to become uncertain, its characteristics will start to change, it will change before you. If we have an idea about what we're going to see, we'll see what we want to see; our preconceptions override our sensory experience. I'm trying to get sensory experience intense enough to unhinge or breakdown our preconception. I'm only talking fractional degrees here. It's what happens when you look or listen closely to something; it becomes vague, it starts to break down. You can imagine what it's like trying to make raindrops listening on headphones, it becomes abstract extremely quickly; after a while your hearing becomes tired; the whole thing breaks into abstraction and turns into white noise.

Nick Stewart I'm interested in your relationship to the history of film and video. Where do you place yourself?

Mike Marshall Bazin described cinema as automated consciousness (Ed. This replaces 'spiritual automata' from original published transcript), meaning that it actually drives thought and perception. I'm interested in these early conceptions of what a cinematic image does, in terms of an image that moves by itself. It's hard to imagine what we even used to think like before cinema and TV. Just consider a jump cut – being able to be in one room and then instantly in another room or situation. Our thoughts can jump from one thing to another, but cinema can displace us from one thing very quickly and abruptly, by something as simple as the sudden appearance of an out-of-place sound. We can understand these techniques in film unquestioningly now, but of course at the beginning such things were probably hard work.

Rose Butler You spoke of looking at things more closely but in the way that you use the hand-held camera and video, you're not looking at something closely. Rather, you're breaking down all the normal structure of the way that we view images and making our experience very mediated. How does that differ between the use of digital image in the video and the way you use depth of focus with a stills camera to create uncertainty in the image?

Mike Marshall I'm trying to look at the periphery of vision and perception. Many of the photographs darken towards their edge. But in terms of a viewer being conscious of something mediated digitally in the video and the relation of this to the depth of focus in the photographs, if you don't mind me saying, it's an academic issue and often people aren't so aware of these discourses.

Rose Butler No, I meant mediated in the sense that you're making the image very difficult to view. Normally when we look at thing, it's really easy, but you're breaking down those safe structures for us.

Mike Marshall I want it not to reward the glance. The small effort of a slight difficulty can be a counterbalance to beauty as an instantaneous or near instantaneous acquisition of symmetry. We get something that is slightly off, but which has some kind of brevity anyway.

Louis Gilbert Thinking of your raindrop piece, were you trying to make your raindrops something more, maybe more 'musical'?

Mike Marshall If you take individual drops and chop them up on a computer, the first thing that happens is that they start to form melodies and rhythms that I don't want, so I have to re-arrange them so that the work is actually doing the opposite in creating a controlled chaos, an orchestrated kind of chaos or disorder. The effort was in making it disordered, but the actual range of texture of the sounds gave it a little bit of musical quality. When we listen to things that are quite unpatterned they take on either compositional or musical characteristics. It's an effect of our perception.

This transcript was originally published in *Transmission: Speaking & Listening, Volume 5* (Site Gallery, Sheffield, 2006) edited by Sharon Kivland, Jaspar Joseph-Lester and Emma Cocker, distributed by Cornerhouse, the event chaired by Jaspar Joseph-Lester with contributions by Rose Butler, Emma Cocker, Horatio Eastwood, Louis Gilbert, Paul Haywood, and Nick Stewart. The discussion formed part of an annual series of public lectures supported by the Faculty of ACES at Sheffield Hallam University, in collaboration with Site Gallery and the Showroom Cinema.

White Building 2007
C-print 36cm x 41cm

Biography

Born, London 1967

Solo Exhibitions

2007

Mike Marshall Union Gallery, London

Mike Marshall Museum and Art Galleries, Paisley

2006

Not Far From Here Pianissimo, Milan

At The Edge of the Known World The Grundy Art Gallery, Blackpool

2005

The Intimacy of Distance Ikon Gallery, Birmingham

2004

Here is Fine Tate St Ives

In The Middle of All This Chapel Row Gallery, Bath

2003

Mike Marshall Union Gallery, London

What if Things Where Different Chapman and Glass Box Galleries, Manchester

2002

Lizard Afternoons VTO, London

2001

Planisphere The Economist, London

Selected Group Exhibitions

2006

Single Shot Various venues nationally

Happy Believers Werkleitz Biennale, Germany

The World is Turning DomoBaal, London.

Episode Leeds City Art Gallery and Florida Arts Centre, Miami

Responding to Rome Estorick Collection, London

2005

Critics Choice FACT, Liverpool

Plural 2 British School at Rome

Episode Temporary Contemporary, London

2004

A Grain of Dust a Drop of Water Gwanju Biennale, Korea

Fantastic Realism Art Hall, Tallinn, Estonia

Pleasure Garden Nottingham Castle

No Particular Place To Go ATP Gallery, London

KIAF curated section Seoul, Korea

2003

Days Like These Tate Britain, London

Senso Unico Telecom Italia Future Centre, Venice

Video 04 Martin Janda Gallery, Vienna

Void Yokohama Art Gallery, Yokohama

2002

The Earth is Flat Ikon Gallery, Birmingham

Cab Gallery Retrospective Essor Gallery Project Space, London

Say Hello to Peace and Tranquility Netherlands Media Art Institute, Amsterdam

Sea Wolverhampton Art Gallery

No One Ever Dies Here... Hartware Kunstverein, Dortmund

Park4tv Cable TV project, New York, Amsterdam, Berlin

2001
Basel Art Fair, VTO Gallery, Basel
Group Show A22 projects, London
Zero Arte Contemporanea Video Programme, Piacenza
Cab Gallery, London

2000
Mul-Te-Pul-Sho A22 Projects, London
Somewhere Someone is Doing Something VTO Gallery, London
Turn On Ikon Touring, Birmingham

1998
Near Sharjah Museum of Art, U.A.E
Bund Projects KX Gallery, Hamburg
Diving for Pearls Submarine HMS Onyx, Liverpool
Everyday Biennale of Sydney
What Difference Does it Make Cambridge Darkroom Gallery
Hamburg Short Film Festival
Twelve Night Festival Video Programme, Bergen
I'm very well thank you you're welcome Studio A, London
Mike Marshall and Liz Kent Bund Projects, London

Awards, Residencies and Commissions
2006
Film and Video Umbrella *Single Shot* commission
2005
Rome Scholar in Fine Arts
2000 - 2003
AHRB Research Bursary

Selected Bibliography
Wilson, Robin, *Architects Journal*, London, January 2006
Graham-Dixon, Andrew, *Independent Magazine*, London, 5 December 2005
Herbert, Martin, *ArtForum*, New York, November 2003
Harrison, Sara, *Art Monthly*, London, July 2003
Coomer, Martin, *Time Out*, London, 13 August 2003
Kent, Sarah, *Time Out*, London, 5 March 2003
Patrick, Keith, *Contemporary*, London, Issue 50

Publications
Happy Believers Werkleitz Biennale 2006
Responding to Rome, British Artists in Rome 1995-2005 Estorick Collection and British Academy
A Grain of Dust a Drop of Water Gwanju Biennale 2004
Mike Marshall: Here is Fine Tate Gallery Publications 2004
Days Like These Tate Gallery Publications 2003
Void Yokohama Art Gallery 2003
Say Hello To Peace and Tranquillity Netherlands Media Art Institute, Amsterdam 2002
Near Sharjah Museum of Art 2000
Everyday Sydney Biennale 1998

Mike Marshall

Published on the occasion of:

The Intimacy of Distance
Ikon Gallery, Birmingham
23 November 2005 – 22 January 2006

Not Far From Here
Pianissimo, Milan
9 March – 9 April 2006

At The Edge of the Known World
Grundy Art Gallery, Blackpool
24 June – 29 July 2006

Mike Marshall
Union, London
30 January – 30 March 2007

Mike Marshall
Museum and Art Galleries, Paisley
10 August – 30 September 2007

Exhibition curated by Nigel Prince with Vincenzo de Bellis
in Milan and Stuart Tulloch in Blackpool

ISBN 978 1 904864 26 4

Edited by Nigel Prince
Designed by Herman Lelie and Stefania Bonelli
Printed by Connekt Colour, UK

All photography and scans courtesy of the artist

Distributed by Cornerhouse Publications
70 Oxford Street, Manchester, M1 5NH
publications@cornerhouse.org
T: +44 (0)161 200 1503 F: +44 (0)161 200 1504

Ikon Gallery
1 Oozells Square, Brindleyplace, Birmingham, B1 2HS
T: +44 (0) 121 248 0708 F: +44 (0) 121 248 0709
http://www.ikon-gallery.co.uk Registered charity no: 528892
Ikon gratefully acknowledges financial assistance from Arts Council England,
West Midlands and Birmingham City Council.

Museum and Art Galleries
High Street, Paisley, PA1 2BA
T: +44 (0)141 889 3151 F: +44 (0)141 889 9240
http://renfrewshire.gov.uk
Museum and Art Galleries, Paisley gratefully acknowledges financial assistance
from Renfrewshire Council

Birdcatcher was commissioned and produced by Film and Video Umbrella as
part of Single Shot. Single Shot is the product of a major new collaboration
between the UK Film Council's New Cinema Fund and Arts Council England.
Supported by Illy.

The exhibition at Pianissimo is supported by The British Council; at Grundy
Art Gallery by Arts Council of England, North West and MITES; at Paisley
Museum and Art Galleries by the Esmée Fairbairn Foundation

The original discussion with Mike Marshall from the Showroom Cinema,
Sheffield, 30 November 2005, first published in *Transmission: Speaking &
Listening, Volume 5* (Site Gallery, Sheffield, 2006). Permission to reproduce
this re-edited version is kindly acknowledged.